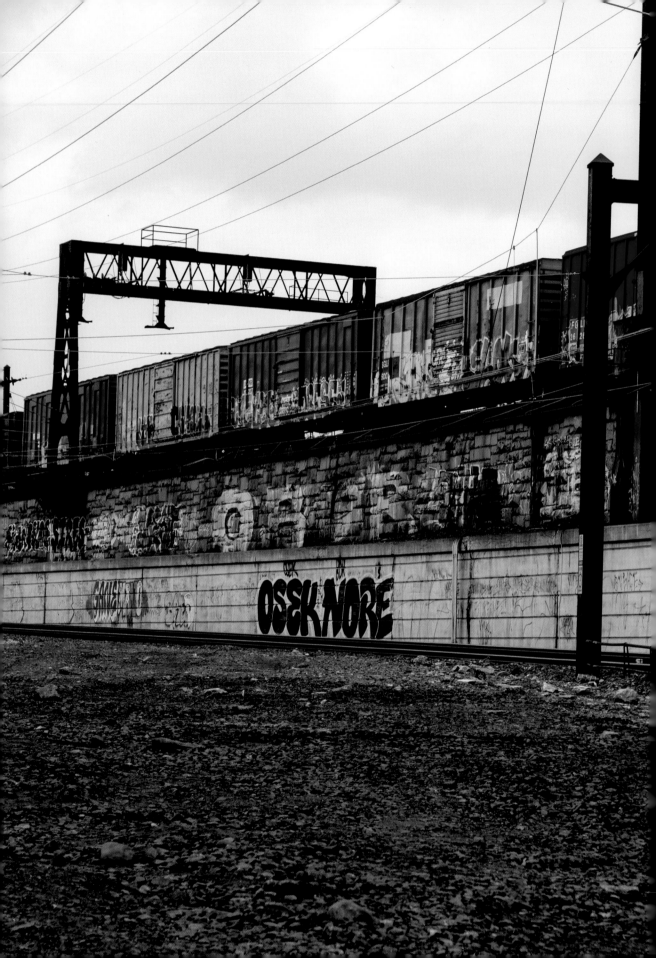

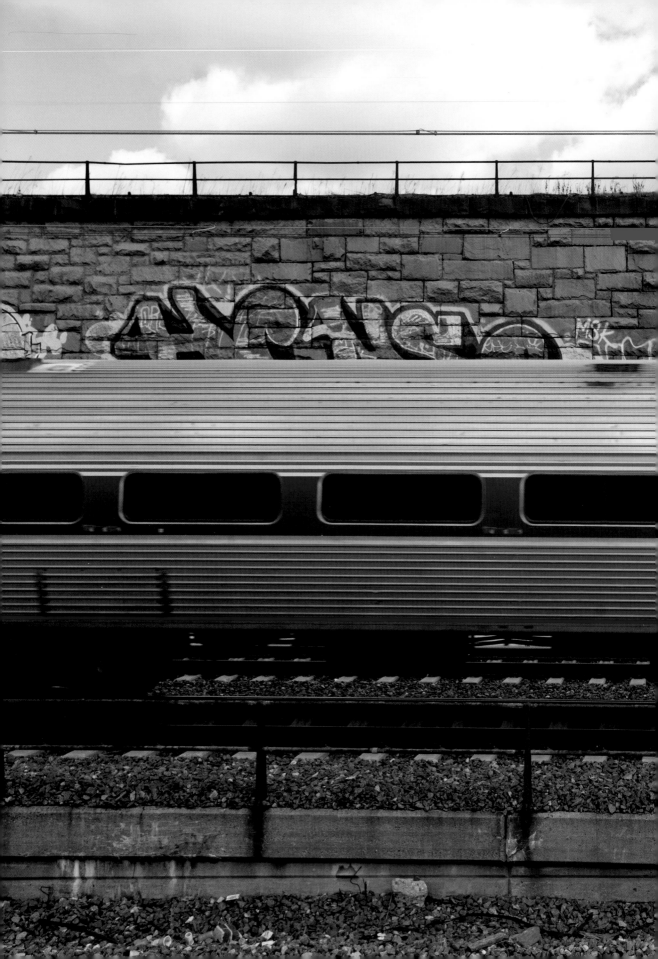

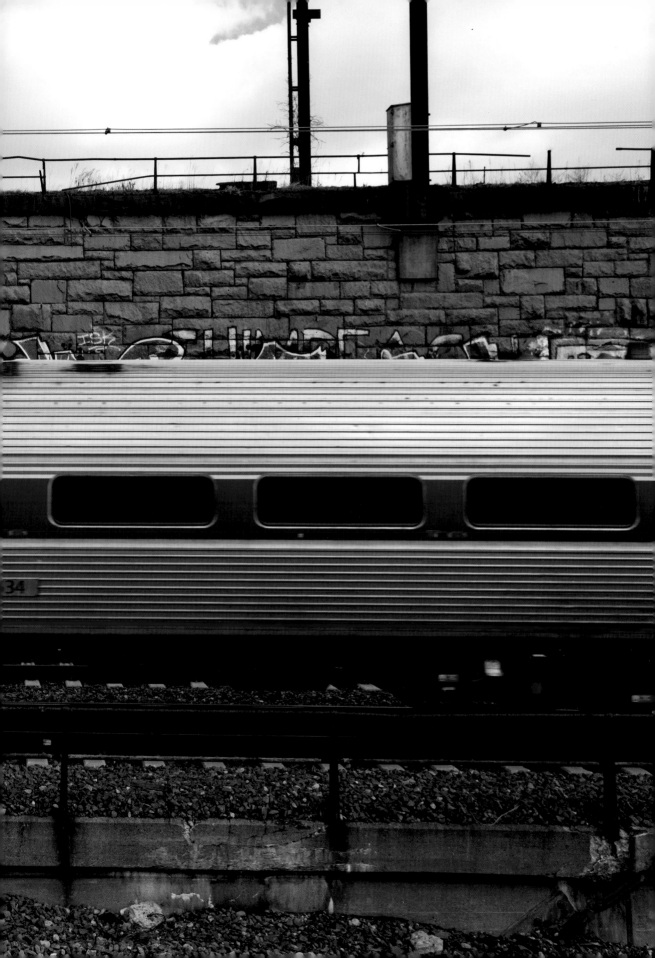

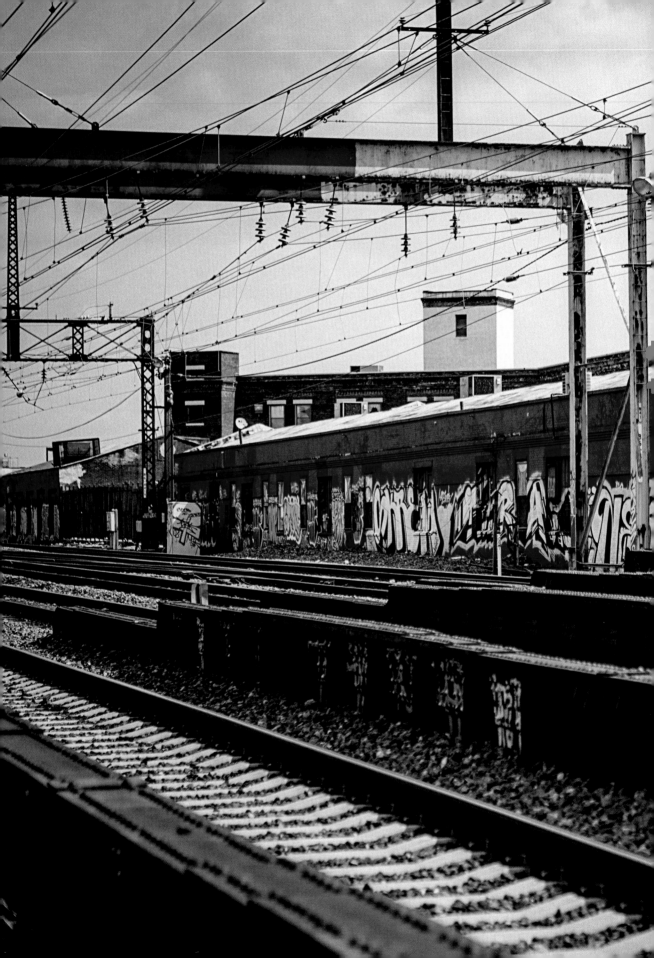

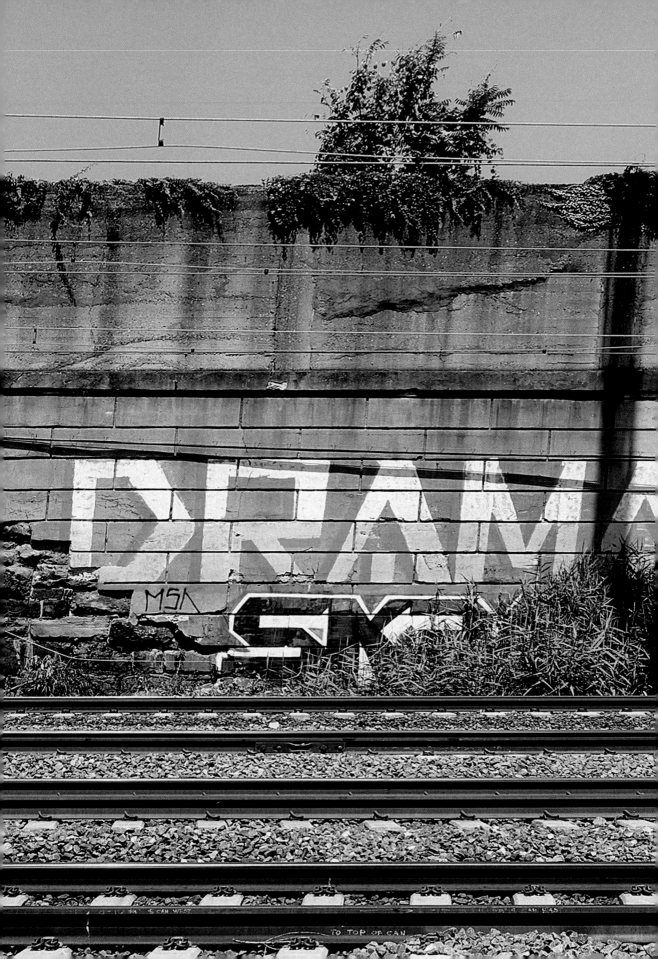

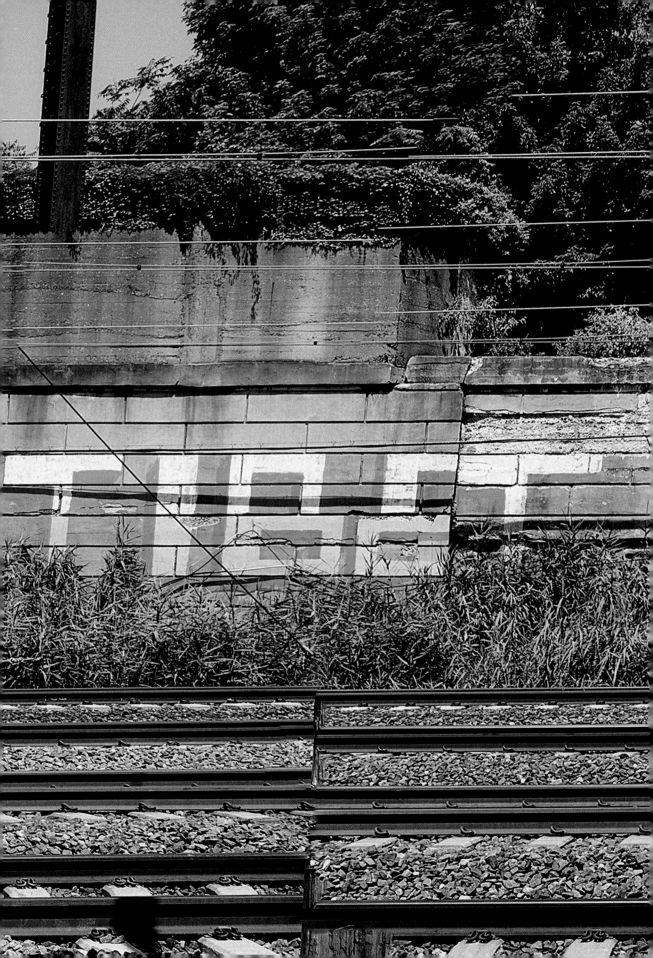

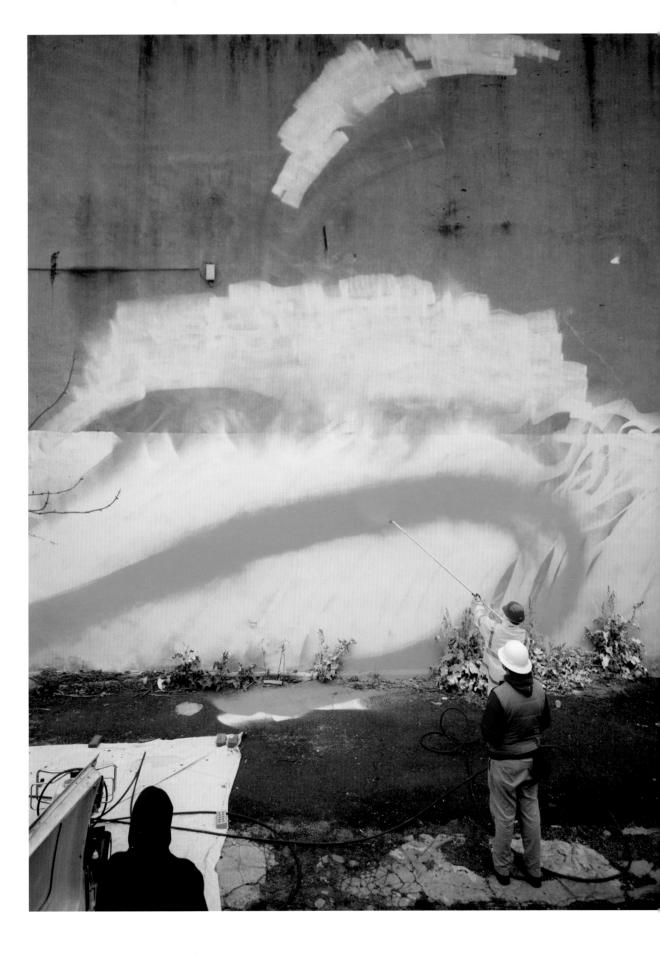

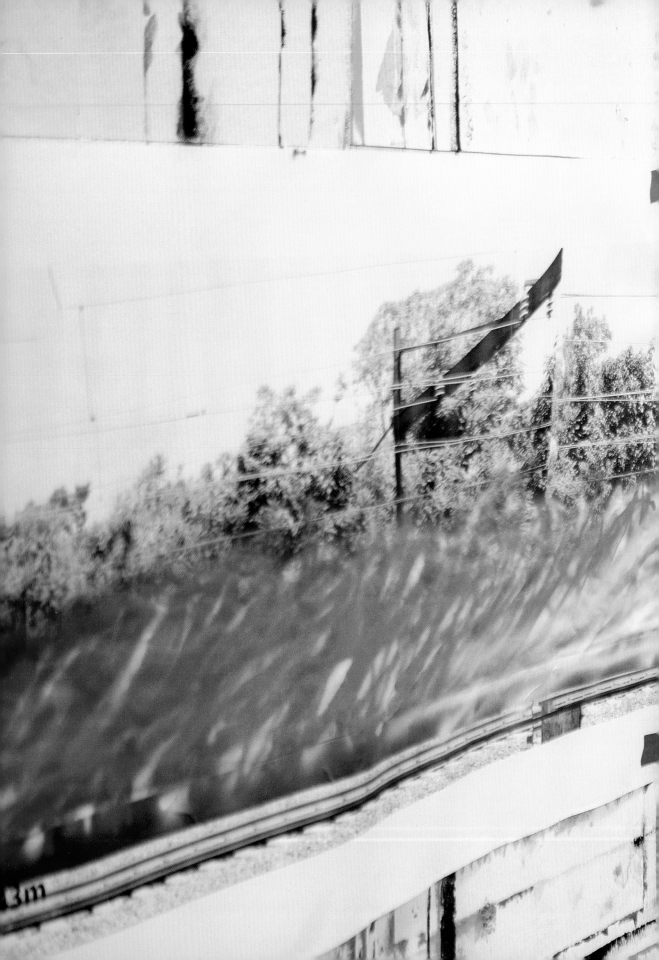

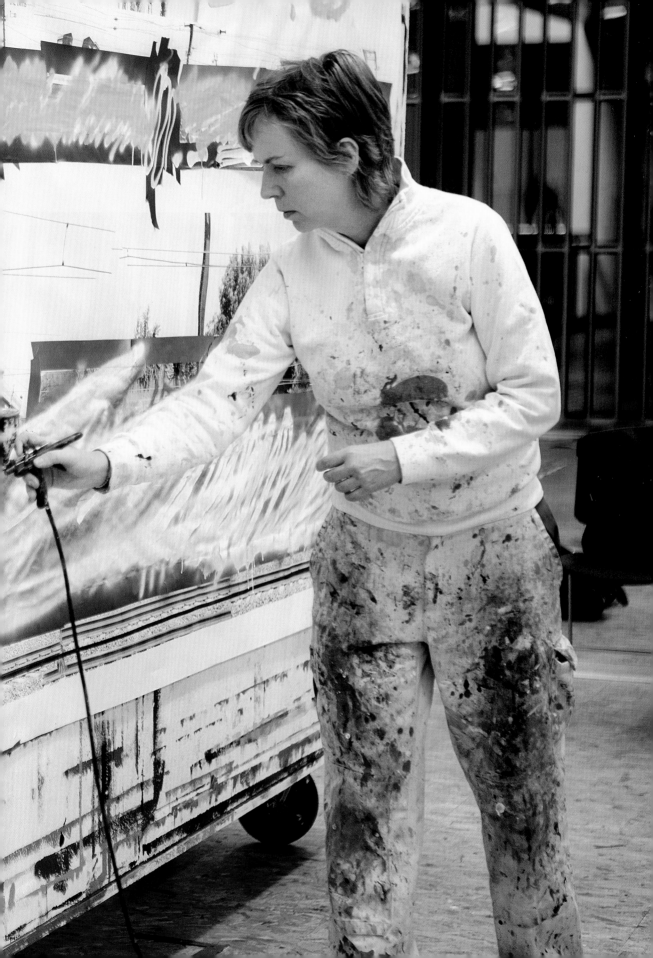

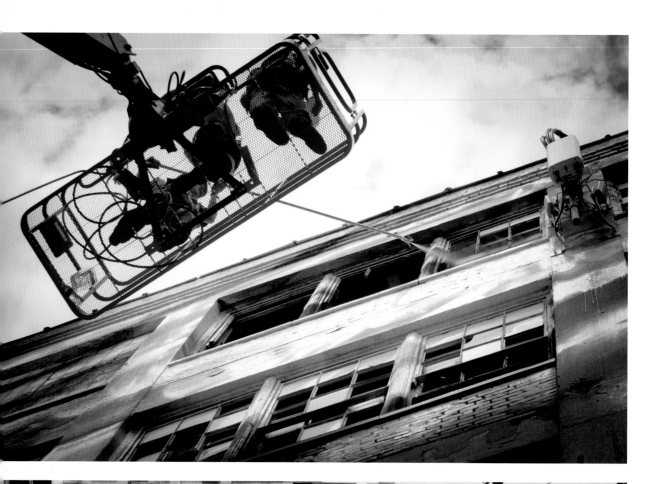
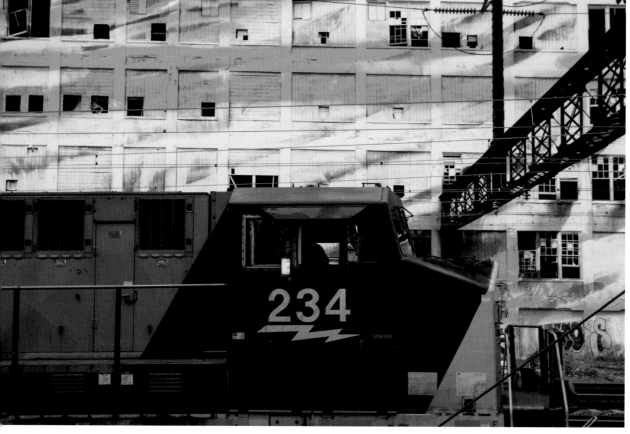

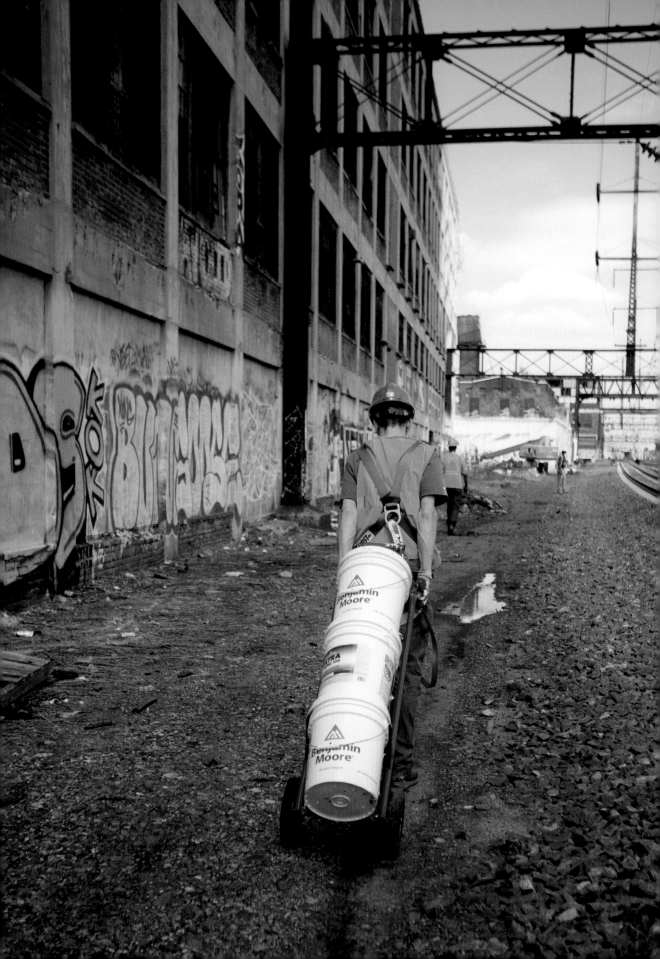

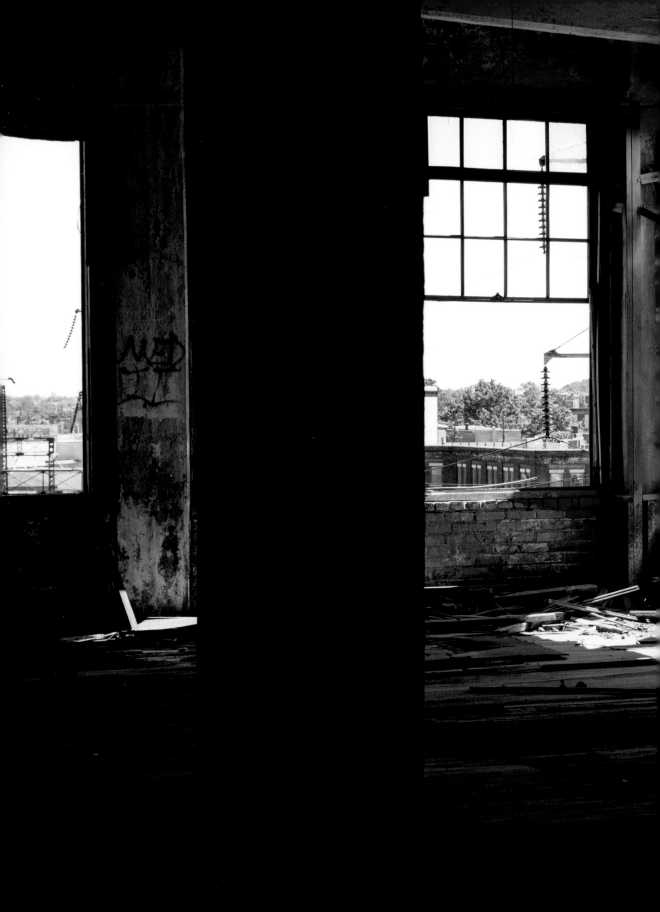

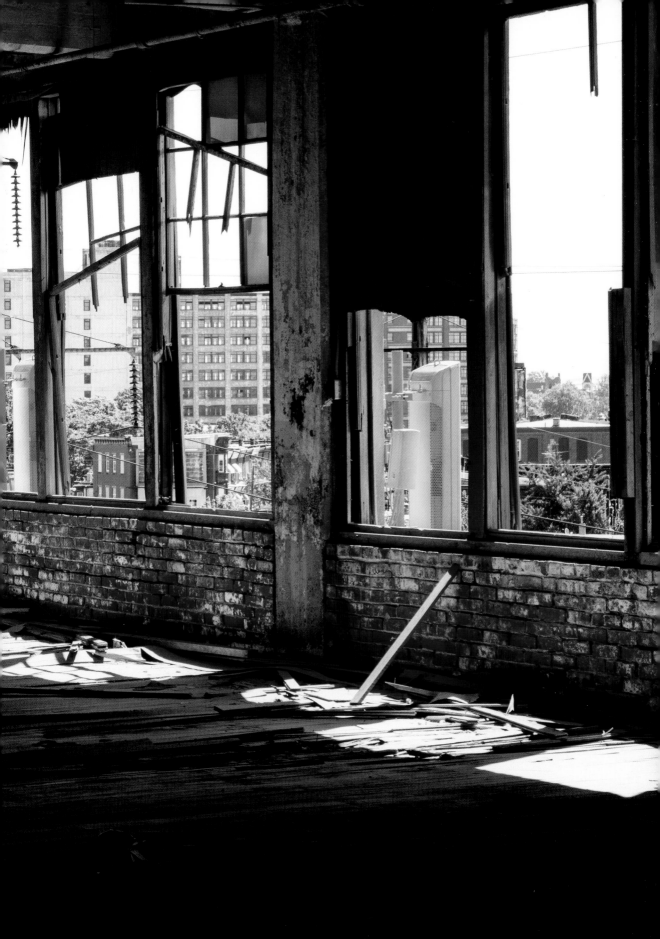

psychylustro

psychylustro

Katharina Grosse

City of Philadelphia Mural Arts Program
Verlag der Buchhandlung Walther König, Köln

Katharina Grosse
psychylustro

Published on the occasion of
Katharina Grosse's *psychylustro*, installed
in Philadelphia along the Northeast Rail
Corridor between 30th Street Station and
North Philadelphia Station in May 2014.

psychylustro © 2014
Katharina Grosse. All rights reserved.

EDITOR
Elizabeth Thomas

TEXTS
Douglas Ashford
Anthony Elms
Jane Golden
Daniel Marcus
Elizabeth Thomas

DESIGN
Project Projects

ADDITIONAL EDITING
Cara Gillotti

PRODUCTION COORDINATION
Judy Hellman

PRINTING
Die Keure, Belgium

PUBLISHED BY
City of Philadelphia Mural Arts Program
Lincoln Financial Mural Arts Center
at the Thomas Eakins House
1727–29 Mount Vernon Street
Philadelphia, PA 19130 USA
www.muralarts.org

Verlag der Buchhandlung Walther König,
Ehrenstrasse 4, 50672 Köln, Germany
verlag@buchhandlung-walther-koenig.de

Special support for this publication was
provided by the Elizabeth Firestone Graham
Foundation.

DISTRIBUTION
Germany & Europe
Buchhandlung Walther König, Köln
Tel +49 (0)221 2059653
Fax +49 (0)221 2059660
verlag@buchhandlung-walther-koenig.de

UK & Eire
Cornerhouse Publications
70 Oxford Street
GB-Manchester M1 5NH
Tel +44 (0)161 2001503
Fax +44 (0)161 2001504
publications@cornerhouse.org

USA & Canada
D. A.P., Distributed Art Publishers
55 Sixth Avenue / 2nd Floor
USA-New York, NY 10013
Tel +1 (0)212 6271999
Fax +1 (0)212 6279484
eleshowitz@dapinc.com

ISBN 978-3-86335-661-3

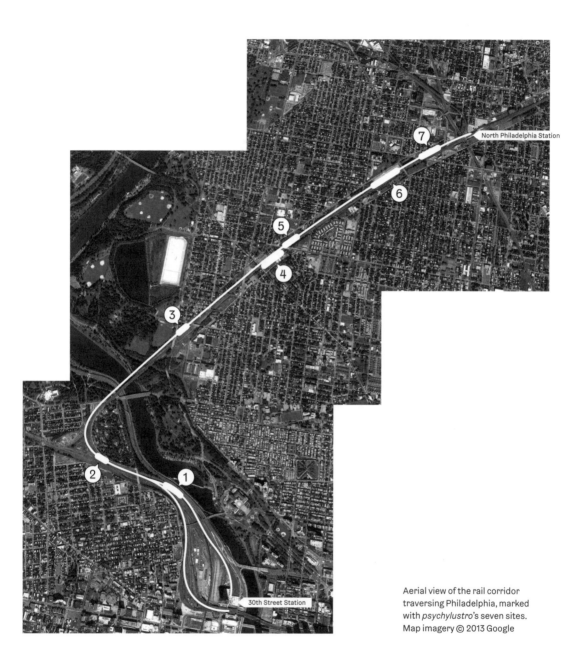

North Philadelphia Station

30th Street Station

Aerial view of the rail corridor
traversing Philadelphia, marked
with *psychylustro*'s seven sites.
Map imagery © 2013 Google

THE BORDER IS AN INVITATION[1]

Elizabeth Thomas

Everything begins with an invitation. Whether offered by another person, occasioned by a context, or even directed to ourselves, it creates an encounter and destabilizes the status quo, opening up space for something new. *psychylustro* represents a series of invitations: to an artist whose practice defied the qualities of narrative and representation that largely defines Mural Arts' practice, from a site so generative it suggested ways of working that were new to everyone, from an artist who challenges coherence and sees past and through the commonly accepted material and spatial boundaries of the given world. Working with Katharina meant learning to see like Katharina, implicating both a kind of indiscriminancy and a sense of limitless possibility, confronting reality not so much as it is but for what it can be, both aesthetically and conceptually.

In truth we arrived along the rail corridor after seeing many possibilities in Philadelphia. The Divine Lorraine, with its evocative name, its mythic and luxurious history, its architectural and spatial complexity, its current state of urban ruin and its pending state of renewal, offered an iconic readymade to react with and against. An empty city block just off Broad Street (the city's north/south artery) offered a surreal blank space within the density of the city to imagine a wholly new situation of aesthetic invention. The elevated

1 I borrow Katharina Grosse's words here, and throughout, to frame this essay.

Reading Viaduct, already provoking the imaginations of urbanists and artists and architects in the city, offered a place to experiment with the social life possible in a bit of wildness, a bucolic landscape just above streel level. But the really interesting thing about working in public is the way in which ideas are occasioned by incredibly varied contexts but then also limited and determined by them, and ultimately the railway corridor where *psychylustro* now lives was the most exciting and also the most possible.

 The corridor offered so much. It offered a different kind of viewing experience, framed by windows and within the psychic space of a train ride (be it for commuting or pleasure) that introduces seriality and scale and speed to Grosse's practice in new ways. It offered a space of tremendous sculptural and material variety, a readymade that brought together so many disparate elements of Katharina's past work, from massive landscapes to facades of buildings, everyday sculptural objects to convoluted architecture, joined in one totalizing spatial expanse. And it offered all this in a space full of its own histories and actions, with its own prescribed and designed use (transit, and the infrastructure that implies) and containing a multitude of individual uses (among them industry, habitation, quotidian activity, illegal activity) in the present tense as well as in its past, all coexisting and layered like a palimpsest.

 This five-mile stretch of railway corridor was initiated in 1864 to connect Philadelphia in all four directions, an engineering and planning challenge resulting in a complex system of interchanges, thereby creating a diagonal path as a mediation of this multidirectionality. Trains pass from the

railyard, across the Schuylkill River, into the back of Fairmount Park, and through residential and commercial neighborhoods, where the grid of the city built up around it. Like most urban rail corridors, industry coalesced on its edges as the city became a manufacturing mecca. In this particular stretch, breweries and their associated industries dominated, alongside the distribution of natural resources like coal and lumber and a litany of other manufacturing—automobiles, textiles, furniture, and other small commercial goods. And like most American cities, deindustrialization in the latter twentieth century left large industrial buildings abandoned, and the neighborhoods that they supported in decline.[2]

 Currently this section of corridor would be understood as transitional by almost anyone, from city official to business owner, visitor to resident. In the most literal sense, it moves us through space, and these radically different zones of landscape and the built environment. For most train passengers, be they regional or local, it is the liminal space between Philadelphia and *not* Philadelphia, and for residents it is a space that is both *of* their neighborhood and *apart* from it, a tunnel for traveling *through* but not *in* this part of Philadelphia. And while it is visually accessible to all, it can never really be occupied or apprehended by our other senses (save for rail workers or the occasional trespasser, who leave behind their physical traces). It represents the kind of liminal space that anthropologist Marc Auge refers to as a "non-place," a transient space where "settling in" is discouraged, social order is obscured, and private and public interests coexist.[3] And so it is transitional in the ways all urban space is

2 Brett Sturm's research and mapping of the corridor, its buildings, and their history represents an important recent resource for the interpretation of the Northeast Rail Corridor. http://philanortheastcorridor. wordpress.com

3 Mark Auge, *Non-places: Introduction to an Anthropology of Supermodernity* (London and New York: Verso, 1995.)

25

transitional, as time and forces—be they civic, corporate, natural, or individual—shape it. It is a place of contradiction, where a warehouse all but abandoned for forty years faces a vibrant community garden, where relics of rail infrastructure sit in ruin next to their gleaming present-day offspring, where graffiti artists lay their own transgressive claim to space as property owners spotlessly renovate buildings for redevelopment.

The corridor is a prime example of what urbanists might call an "ordinary landscape," a space where the built environment of nature and architecture reveals and produces a cultural landscape to be read, studied, and analyzed to tell larger histories of economics, politics, and social forces.[4] It combines elements of both the designed and the vernacular, bearing traces of civic-level planning and individual intervention in both action and neglect. The specificity of the rail corridor creates what might be considered a blur landscape, one that, due to density and speed, is hard to distinguish specifically even in concentration, and that is more often understood only peripherally as a undifferentiated collage of leaf and sky, metal and brick.

So everything can be seen I paint blindly
Grosse's work lands in the corridor after decades of experimentation, her practice characterized by its palette of pure, heightened color and its site-responsiveness through the performativity of her process. In previous work, both interior and exterior (and in between), she practices a particularly aggressive kind of painting, occupying floor, ceiling, wall, and any number of elements of her own generation, including

4 The canonical work of the field is Meinig, D. W.; John Brinckerhoff Jackson, et al. *The Interpretation of Ordinary Landscapes: Geographical Essays.* (New York: Oxford University Press, 1979).

sculpted foam, rubble, concrete, dirt, or found objects. She trespasses with paint—invading, transforming, and at times obliterating—doing the wrong thing not for the sake of misbehaving, but for the sake of rupturing and complicating a given spatial order to create her own. Color is applied as much to dissolve form as to generate it, collapsing dimensionality or merging the boundaries between discrete architecture and objects. Her characteristic spray technique creates a kind of surface equivalency, as the haze of paint hits discrete objects and disparate textures without the trace of a brush to throw such differences in relief. It produces one of the central contradictions of her work, the use and abuse of paint as something that simultaneously cedes and asserts form and boundaries, just as her work simultaneously generates illusion while asserting its materiality. For Grosse "everything is illusion, not *an* illusion (as opposed to a reality)." She doesn't abide the separation of discrete objects, neither visually nor in reality. Her work diffuses borders and boundaries between things, and fashions limits on the interiors of objects and architectures, not on their edges. This is one way she paints "blindly," to see false separations and boundaries between things visually, but also socially, culturally, historically, suggesting the deeper connections that link not just objects and things, but also suggesting their physicality binded to people and ideas inseparably from each other.

I do not work against *anything but* with *everything* *psychylustro* takes on the material and contextual contra-dictions of the corridor directly. Brilliant color appears along

its elemental rubble, within its eruptions of wild nature, over its decaying relics of infrastructure, on buildings both developed and in ruins. Its presence marks points in a recurring cycle of human progress and the forces of man and the natural order that work with and against it. *psychylustro* works with all of it, not just where the color alights, but also the interstitial spaces in which paint does not appear. Its seven passages engage deliberately, chosen for their symbolic value and material variety as independent sites, and for how their aggregation creates a choreographed experience and a larger conceptual whole. Each passage allows its own exploration of paint on surface, from the architectural and spatial complexity of whole buildings to the textural complexity of surfaces that transition between concrete, rock, rubble, and nature in a continuum, creating an aesthetic experience that defies categorization, as wall painting, as installation, as urban earthwork. Grosse works *with* the corridor, and *with* the temporal implications of its liminal and transitional character, that hold past and present and future the same way a painting holds the time of its making and the time of its viewing.

Bombastic in scale and surreal in hue, it shocks the corridor's system, heightening both the presence of features in this "ordinary landscape" and the presence of viewers in themselves, whether in rapt attention or in peripheral flash. Grosse likens *psychylustro* to a phenomenological event, like weather, something that happens within the world that changes things both immediately and in deferral. Despite the brashness of its marks, the hyperreality of its colors, the scale of its presence, it settles into the evolving ecology of

this "ordinary landscape," reimagining and redefining it presently, but fading and taking its place as one layer among the many natural, social, human, and economic layers over time, its lingering effects embedded in the landscape. The paint (interior, zero VOC) is chosen for its relative impermanence, unsealed and open to the elements of nature; the sites as well, from the natural passages largely reclaimed in the wild growth of summer, to the walls that may be marked by graffiti, or restored to raw brick in the process of redevelopment. *psychylustro* works *with* the corridor, and the corridor works *with* it, an acknowledgment of the instability of all things, material and otherwise, in light of forces like entropy, and time, and human intervention.

To work *with* the corridor, scale operates on more than one level—mere surface area, scale of gesture, and scale of duration. Each mark arrives on the massive surfaces to match its size, as if casually drawn by a superhuman hand. The effortless appearance of the marks belies a process that supercedes the singular artist, and implicates many artists and many tools. They are possible through the use of industrial equipment, massive sprayers and special nozzles that pressurize a wide swath of pigment, extension poles that extend the reach of the body, and lifts that can smoothly move a body up, down, and across large expanses. And they are made not by a hand, or even an arm, but by whole bodies in motion—walking, twisting, arching to craft fluid and effortless lines that mark the execution of a kind of impro-visational choreography. The choreography occurs not just in the space between thinking and acting for a single painter and their tools and their surface, but through a team of

painters who form part of some larger embodied whole—
the mark can not be made by the painter without the others
who drive the lift, or manage the long hoses that channel
the paint from the machine, or that stand at a distance to see
the totality of the surface. These methods produce work
that feels massive if beheld in a fixed position: But the move-
ment of the train complicates our sense of scale, its accel-
erated pace quickening the miles to just minutes, and the
massive surfaces to fragments seen through the intimacy of
a window. In this *psychylustro* offers an experiential journey,
but it refuses to resolve as a singular aesthetic whole, as
an image of it can not be fixed, and mingles with the
"ordinary landscape" that surrounds it, to be layered with
other passages.

*It is important to me that there is no singular
point of view, so there cannot be an coherent image.*
Grosse's work has been characterized by an absence of
totalizing knowability. Increasingly as her work has grown in
size from that of a painting, to a room, to a building, to the
city itself, this has implied a physicality of spectatorship
and viewership, a body moving through space to make and
remake its own aesthetic experience from the varied ges-
tures and surfaces and actions. In the case of *psychylustro*
its largeness can be said to generate a kind of largesse,
implicating the mutability and individuality of physical and
aesthetic experience in its refusal to be taken in all at once, or
even continuously, because of scale and situation. But that
visionary multiplicity is a metaphor for a much broader sense
of its possibilities, as its unknowability opens generously to

31

contain the intentions of many—the artist and the curator, the team of artists who helped to realize it, the organization that commissioned it, the city that receives it, the transit agencies and property owners who facilitated it, the viewers who experience it, whether once or dozens of times. The singular understanding of what *psychylustro is* is simple in description, but impossible in experience. The singular understanding of what *psychylustro does* is equally inconceivable, implicating the layering of intention, of thought and interpretation, like so much paint as it meets surface, changing and being changed by it. *psychylustro* offers a series of propositions about how art lives in the world, what painting can be, what uninhibited thinking in public can model, how contradictory systems coexist (be they social, economic, natural, or aesthetic), and how we change the world through the act of seeing, every time, everywhere. Grosse reminds us that "reality is a performative activity that generates itself newly and differently, again and again." And her gesture, far from final, far from dominant, intends to generate our awareness of the current states of the railway corridor, in the presence of her actions and the spaces that remain untouched around them, and in our imagination for its future state. Not a declaration. An invitation.

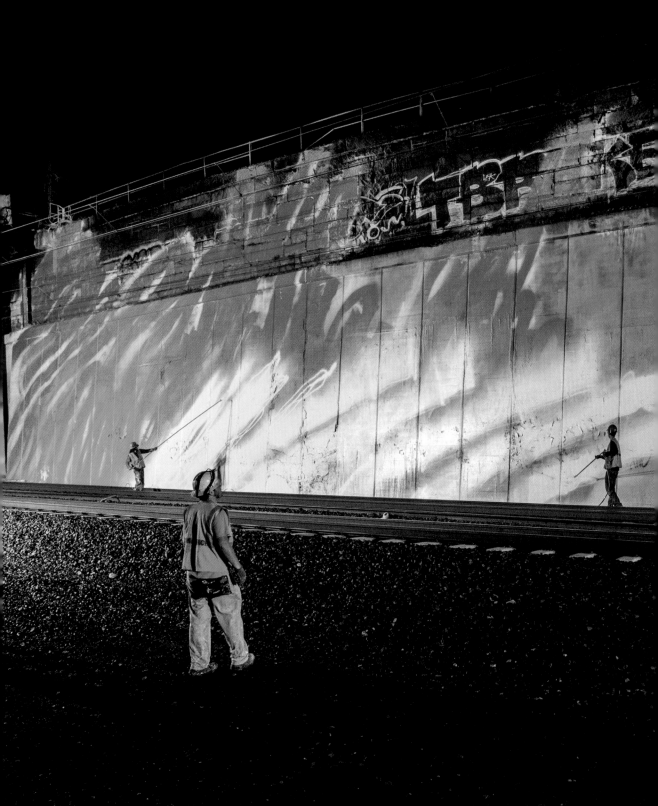

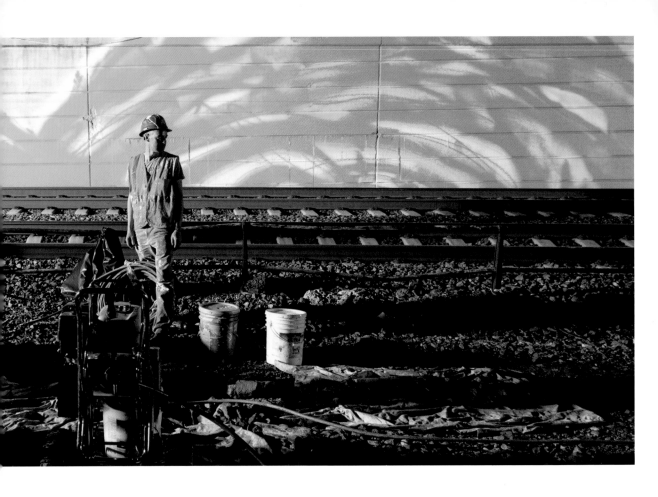

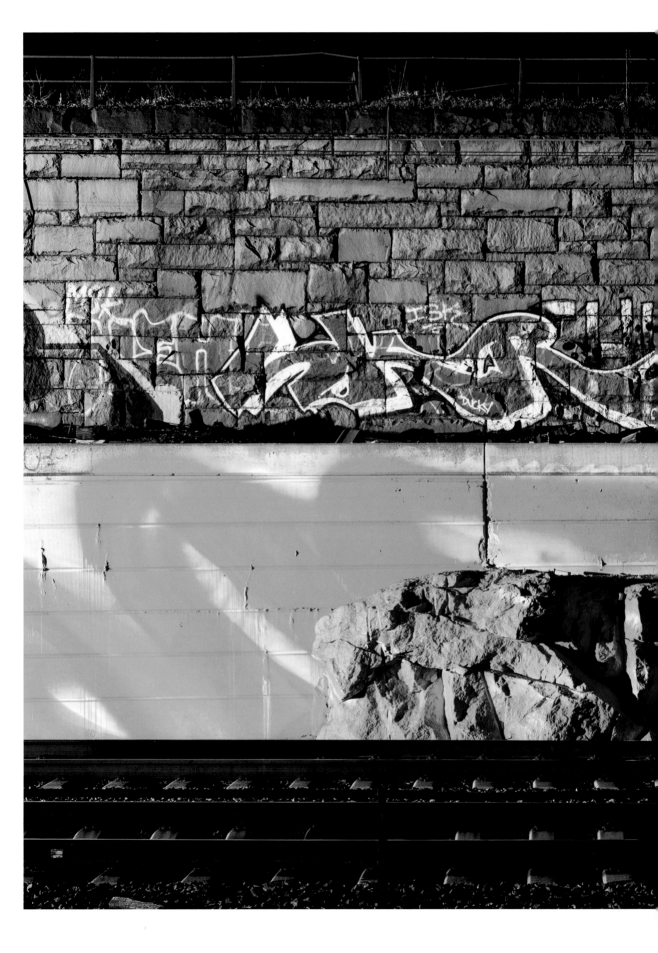

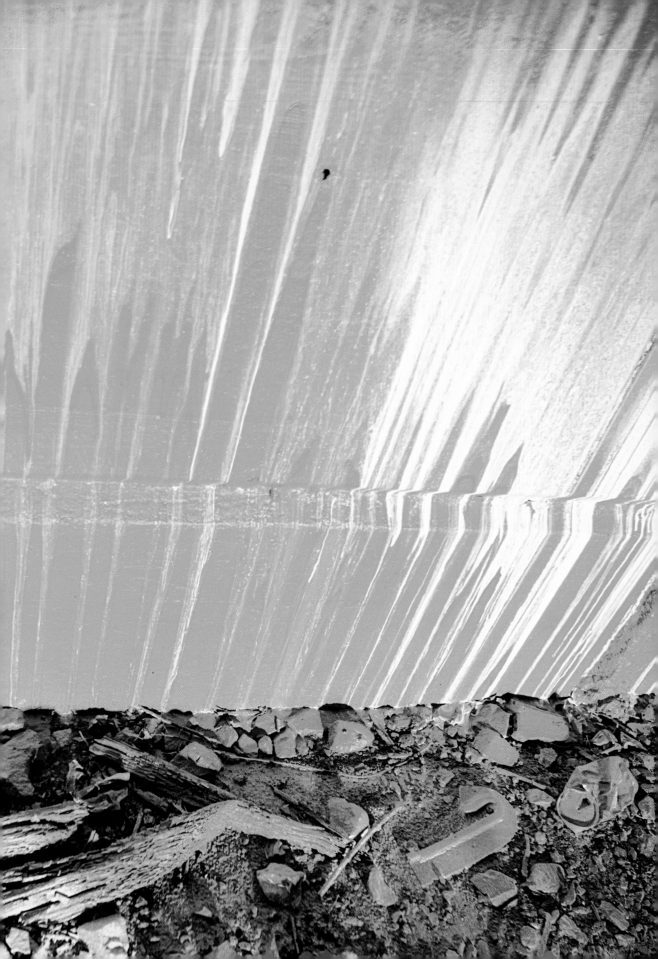

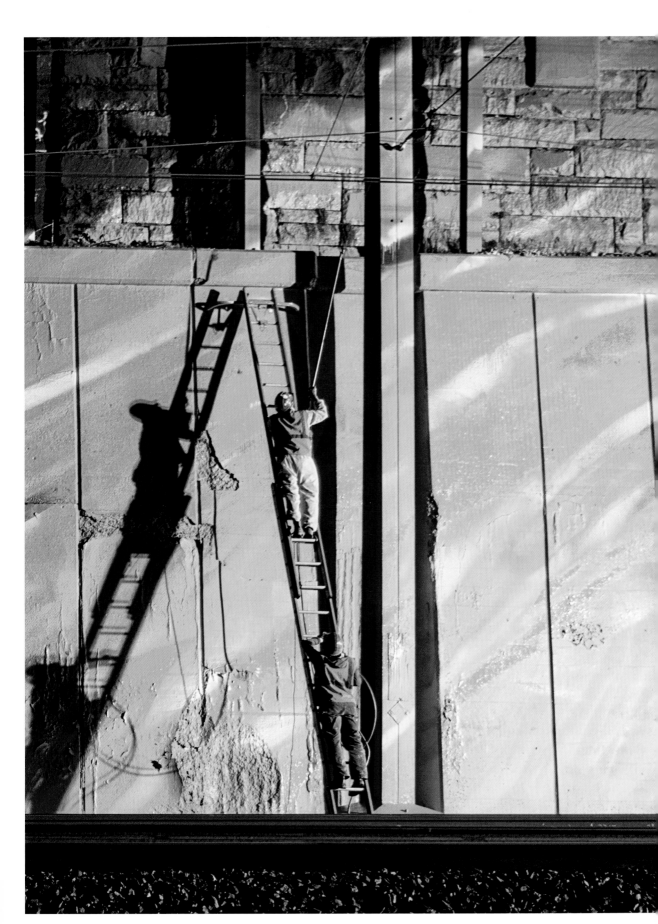

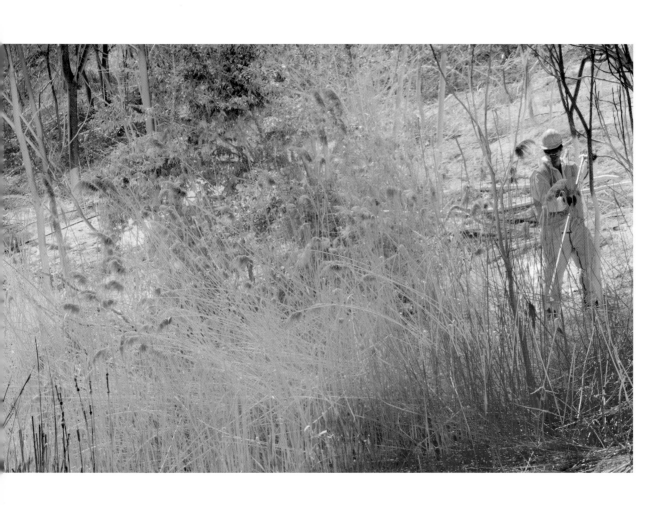

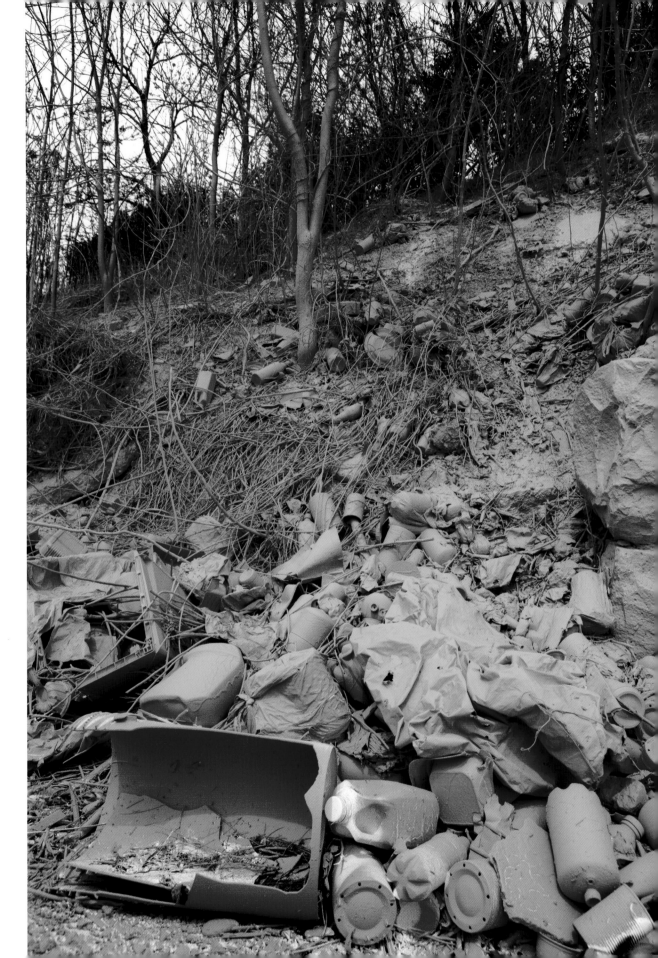

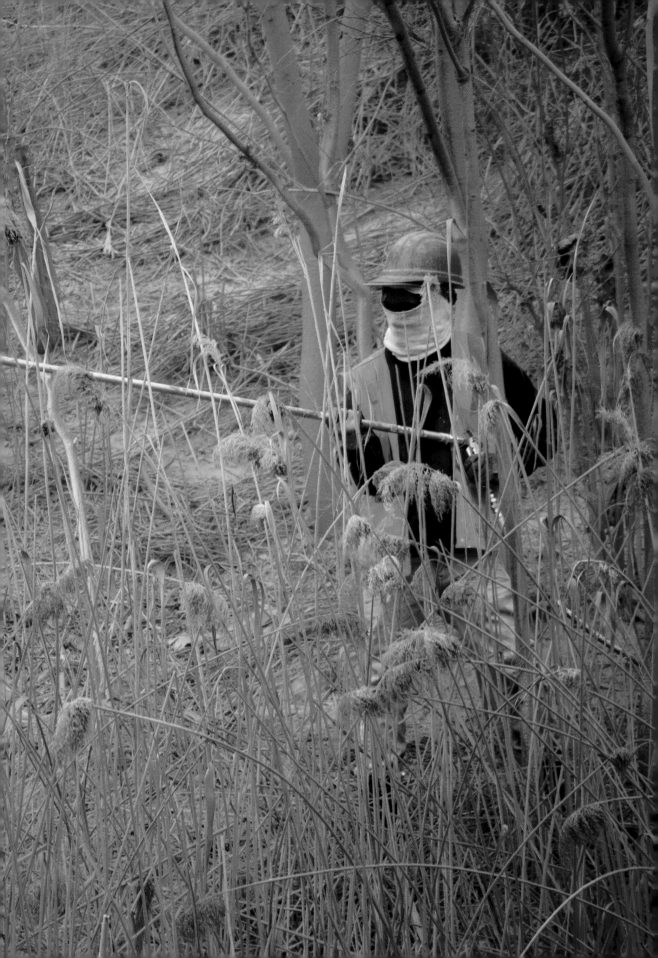

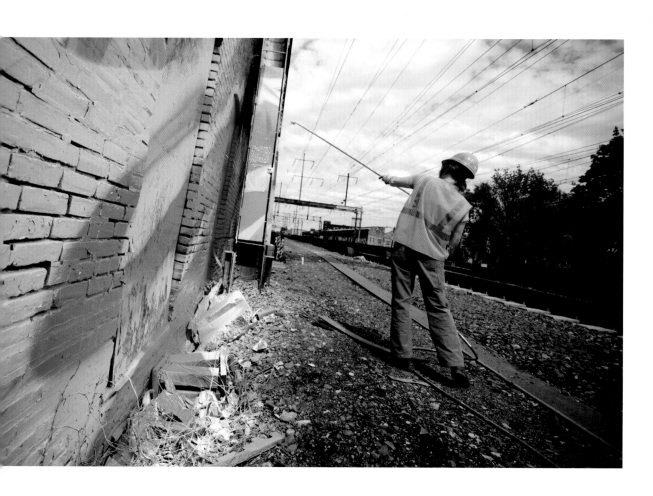

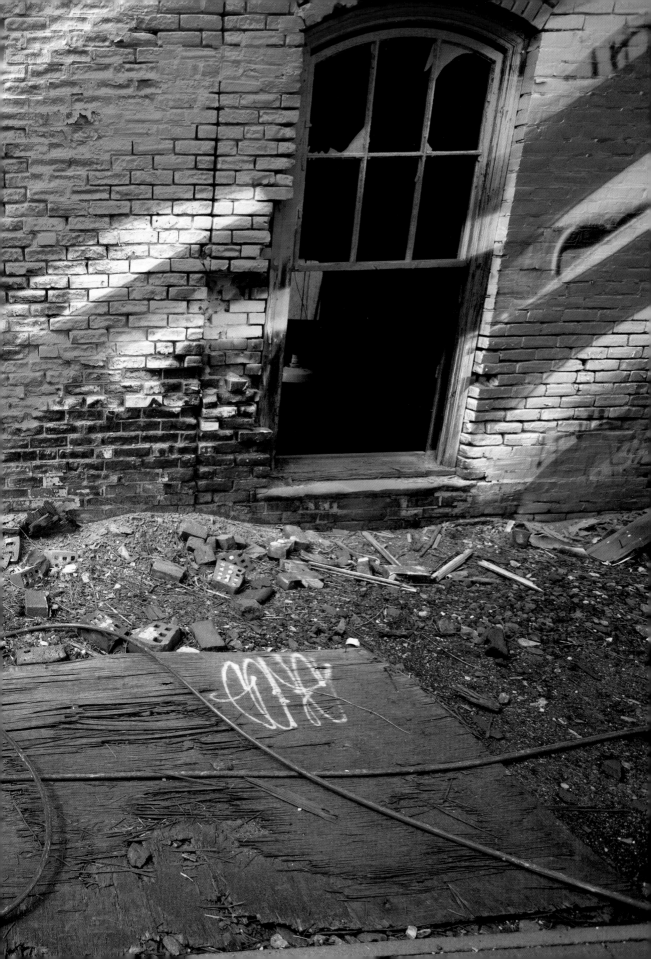

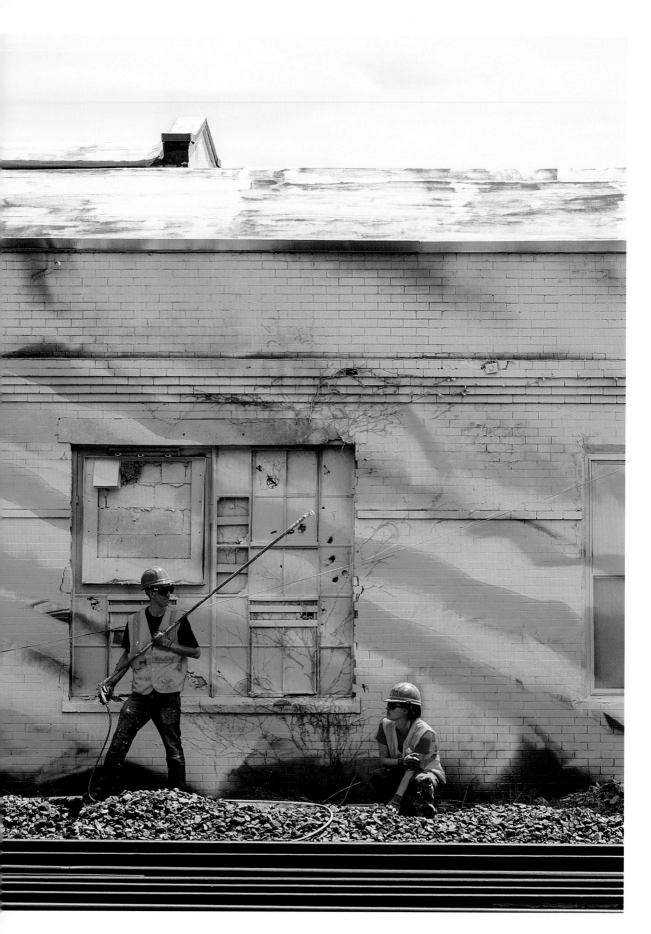

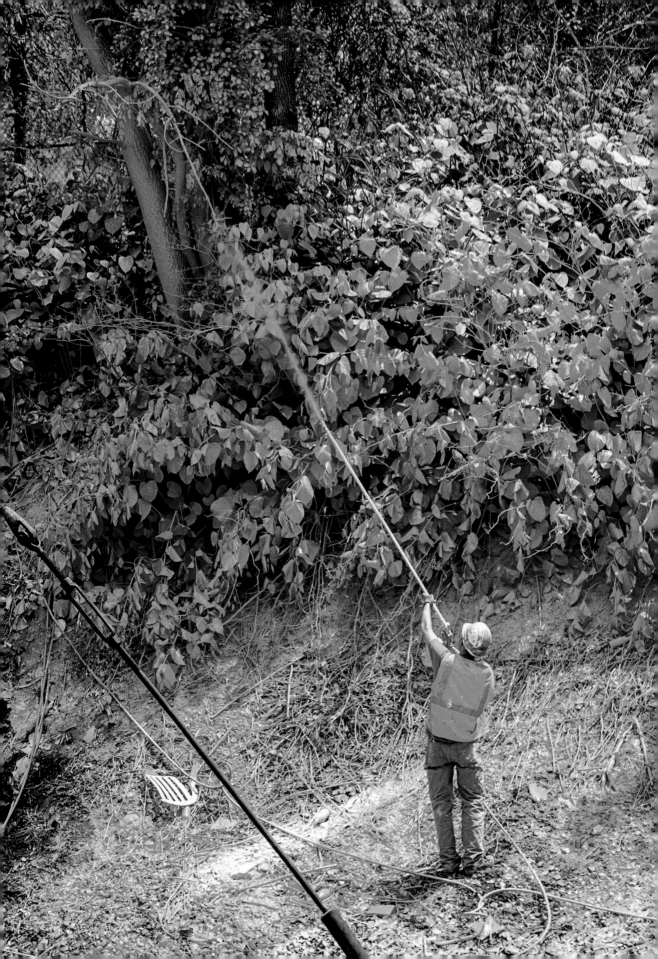

PROXIMITY IS WHAT IT IS

Anthony Elms

Katharina Grosse makes paintings on paper, on canvas, and other portable supports, rectilinear and not. She is perhaps most noted for her paintings that fill architectural space—on walls, ceilings, floors, windows, doors, columns, grounds, and objects collected and assembled. Paintings, not wall paintings. They do not adhere to or enhance the architectural space—in fact they often fight or defy the space. Paintings, not sculptures, not installations, not multimedia. They always adhere to a language of painting in color, gesture, compositional strategy, frame, and border. If we label Grosse's works incorrectly, we misunderstand that there is no one speed, shape, ramification, or encounter to painting. The intention, the painting tool, the movement, and the resistance of the surface are together the painting. Not in a metaphysical sense, in a very literal and visible sense. Attune closely to Grosse's painting: She primarily uses a spray gun, and the distance and diffusion of the tool are always present. One sees when the liquid spray was close and dense enough to saturate, soak, drip, congeal, and also so distant as to lightly graze or lose clear boundary. The distance between her discrete paintings and the building-scaled paintings is not a change of method, only a change of surface and its resistance to or acceptance of paint, and most importantly a change of scale.

49

When I say Katharina Grosse's best paintings will not last, it is not because her paintings that fill architectural space are up for an agreed-to period of time before the objects hauled out and floors, ceilings, and walls return to white to receive the next exhibition or use. Constructions of pigment on surface appear robust, immutable. And yet compounds in paints break down (some quicker than others), many pigments are prone to fading and transforming, the materials (wood, canvas, board, aluminum, etc.) of the structures and supports of paintings easily fall to ruin or blemish. Observing a painting that wears just like architecture wears draws attention away from composition as a clearly defined formal plan and toward the recognition of composition as a temporal encounter in space. Grosse mentioned in conversation that she is "allergic to composition" and "loves to watch things grow." In growth is the inevitable: bruising, wear, unevenness, and overgrowth—all of which challenge the primacy of fixed composition. You sense that when entering one of the building-scaled paintings and their impasses—the conflicts, splay, bald spots, roundabouts, shards, discrepancies. Paintings like *psychylustro* are not located or on location or exactly in a location: these paintings make location. Referring to her room or building-scaled paintings, Grosse commented, "There is no place to hide." As you try to take in the building-scaled painting, you are always located in space and outside form relative to her painting, which is a space just like any room. Yet fluidity and haze and antagonism and mass—of hue, of saturation, of edge, of shape—resist the hierarchy of a built wall. Rather than a painting on a wall, a gangrenous

cluster of deep smog hues gathered near a corner (to offer one example) is the inside of a body created with the help of the architecture of the setting. Inside forces the existence of an outside, crafted during immersive adherence to, around, and under spaces. Standing within these paintings, you have an experience counter to a rational sense of architectural thinking or structure. Step inside, and outside, the functional norm of space in just two footsteps.

Location as crafted by Grosse sprawls farther when language gets involved. Attempted material descriptions, not to mention the titles offered by Grosse, have a concreteness and crispness that fuels metaphorical, fantastic, allegorical contingencies. Descriptions might include: neon pink field of weeds; silver-congealing ghost couch; murky-moss fuzz corner; polystyrene glacier jutting from acid-tinged field; rumpled rainbowed clothing; cinched, mottled-fabric monochrome; primary islands around secondary color archipelagos; splotched, felled tree trunks; technicolor soil mounds; cool-toned floating spherical glow cluster; atmospherically-striated carpet tempest circle; spidery contrast expressionistic corner; non-Euclidean blaring yellow arc streams. Sample her titles: *Wer, Ich? Wen, Du?* (Who, Me? Whom, You?); *I Think This Is a Pine Tree*; *Just Two Of Us*; *Wunderblock*; *Two Younger Women Come In And Pull Out a Table*; *Third Man Begins Digging Through Her Pockets*; *The Blue Orange*; *They Had Taken Things Along To Eat Together*; *One Floor Up More Highly*; *This Is Not My Cat*; *Atoms Outside Eggs*; *Faux Rocks*; *Something Leadlight*; *The Poise of the Head Und Die Anderen Folgen* (And The Other Episodes); *If Music No Good I No Dance*; and *Cheese Gone Bad*. This isn't

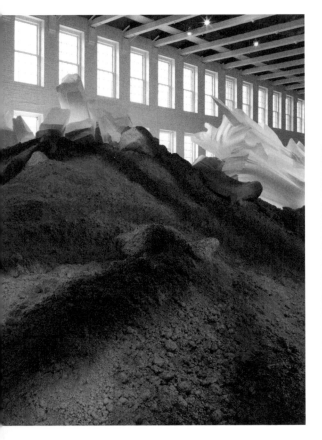

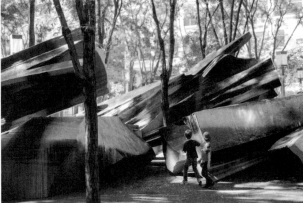

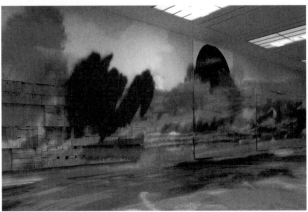

left: Katharina Grosse, installation view of *One Floor Up More Highly*, 2010, at MASS MoCA, North Adams, MA. Soil, wood, acrylic, Styrofoam, acrylic on glass-fiber reinforced plastic, and acrylic on canvas.

top right: Katharina Grosse, installation view of *Just Two Of Us*, 2013, at MetroTech Commons, Brooklyn, NY. Acrylic on glass-fiber reinforced plastic. Commissioned by Public Art Fund.

bottom right: Katharina Grosse, installation view of *Double Floor Painting*, 2004, at Kunsthallen Brandts Klædefabrik, Odense, Denmark. Acrylic on wall, bookshelves, and canvases.

a lugubrious list of phrases trying to describe the facts of a Grosse painting, nor are the titles coy titular allusions. Structurally, *Third Man Begins Digging Through Her Pockets*, for example, offers details of how she engages and reacts to a space. Clear, descriptive phrases give one simple action or a clear relationship to either a space or an action, albeit an action the results of which we have difficulty drawing the limits of exactly. Simple modifiers of simple items lead to an oblique crossroads, as they don't obviously lead to a fixed state. This draws us into the paintings deeper, looking at her direct—even deadpan—transformation of architecture, visual details piling up alongside the declarative language of the titles and our own ongoing naming as co-pilots.

Encountering Grosse's building-scaled paintings, we stand with material facts, a substantial number of which—the painted striations and fields—point toward abstraction and formalism and an irrational space, all generally thought of as not of *real* space. The support for painting in these cases—floor, wall, window, clothing, and furniture—couldn't be more quotidian. The resultant with and within (I stand with a painted couch within a garishly conflicted color field cloud) causes a very physical intrusion by the painting itself, whereby it gets out of its body—canvas and frame—and lurks amongst us but never seems made exactly of the same physicality that our bodies inhabit. Still, standing within one of her paintings, we can see the paint is treated commonly—it gets scratched, dust collects, cloth slumps, dirt sags and clumps, grass grows, and footsteps ruin the pristine spray of the paint. The stability of the paints and materials on offer asks us to witness a self-aware aging of painting, reminding

53

you a touch of your body and the temporality in movement—
the friction between two or more materials cohabitating and
changing each other.

Temporality is relative, and we are active co-
generators of fictive or representational time and markers
of navigational pace with the world. JG Ballard writes
in *Millennium People* (2003), "It's not what you believe: who
really knows? Far more important is the map you draw
of yourself." How our mind draws our bodies into space has
as much bearing on our navigation of that space as
any supposed material facts on the ground. Grosse casually
mentioned to me both theater (specifically Pina Bausch)
and mountain climbing as possible points along the
way she approaches painting. There is no way to accurately
do justice to Bausch here, except to say that Bausch's theater
distinctly sets very physical and direct actions relative
to emotional states, a sensual understanding of setting, and
seemingly simple objecthood with a language of abstraction,
something without a doubt important to engaging
Grosse's paintings. Given the title *psychylustro,* following
Bausch's movement, my mind immediately clears a path
to psychophysics: a form of psychology aimed at quantifiably
recording and analyzing how physical stimuli affect per-
ception. Keep all this in mind, to now think about mountain
climbing, it's one step at a time, and you must find
your footing before continuing. Climbing terrain cannot
be surveyed at safe distance or overview; you need to feel
your way, literally, and any abstract notion of how best
to move forward must engage if not in concert side-by side,
then in productive counterpoint, to the terrain. And to return

to Ballard, as if in an anticipatory retort to his later self, from *Empire of the Sun* (1984): "Never confuse the map with the territory." Map in mind and action in foot, if you aren't alert to the in-flux gap between map and territory, in mountain climbing at least, you're likely to end up a splat. For most cases the demand to remap regularly engages, and in response we confuse map for territory repeatedly, just one of many ways that Grosse's paintings excite. They confuse us further in and forward.

This confusion is a perfect example of architecture as much more than bricks and beams, windows and doors, fixed use and code. Architecture as extrasensory to form in the ways it reworks or resists the structures and buildings used to confine identities or functions. Via a number of books and essays spanning two decades, Jill Stoner and John Paul Ricco have worked to build on the idea of "minor architecture," as developed by architect Jennifer Bloomer in earlier writings. An overly simplified explanation: "minor architecture" recognizes the way genders, politics, and sexualities who were not presumed to be acceptable clients or communities for a building inhabit hostile or indifferent architectural spaces made for someone else's desires. In fact, these communities need to undermine the concrete directives of the built in order to even have expression through social space. Often these communities develop subtly subversive ways, often imperceptible to outsiders, to move alongside and within the built environment while enacting values and needs in glances, accents, redirections, mispurposings, disregardings, and recodings.

Grosse does not set herself out as a proponent of "minor architecture" nor does she speak of it; and I do not see her work as an illustration of it per se. Still, in the way she works inside and outside of the structures she paints, we can see echoes of how "minor architecture" crucially marks our way through spaces. Her building-scaled paintings largely occur in spaces designated for art, and still when we encounter this work we feel that the paintings are not exactly what the space was designed to house. The paint and additional surfaces and structures, and Grosse's tendencies toward pop artificial arches and zapping lines and clouds of many colors, set an understanding of space that will not abide by proper use, clear entry ways, or exit paths. This flux of real and inferred, a flux of *thinking while undertaking*, is undeniably an erotic response in inhabitation. And undeniably, Grosse's painting is an erotic response to the places she paints. Tactile surfaces are touched, coated, repurposed, repositioned, smeared, and set adrift with a new tactile sense: Blank walls blow out, ceilings and floors drop out, curve in, engulf. Her aesthetics are rendered as material facts and social spaces. You are placed between the painter and her surface in time. All paintings by Grosse engage a start-stop, start-stop: In tempo, form, and place, the paintings insist on heightened encounters through tactile repercussions and social grounds as the only way space can be encountered. As an analogy, Michael Bracewell writes in "A Letter to WH Auden" (2012):

> Even on special occasions, such as a birthday, or Christmas, it always seemed to me that the core of

the day's enchantment lay in communing, in solitude, with its temporarily forgotten commonplace aspects: the undecorated room, away from the festivities; some corner of the garden, out of sight of the party. Perhaps this was a way of intensifying my pleasure in whatever celebration and treats such days held; to bathe in anticipation and sharpen my senses, by absorbing the atmosphere of the commonplace, as it stood in thrilling contrast, its banality highlighting expectation, to the immediate availability of exotic fulfillment. Thus the gourmet takes a sorbet between courses of a rich meal, and the experienced libertine finds their greatest pleasure in some subtle pause before the debauch.

Perhaps *psychylustro* offers this in a most exaggerated way due to its necessary experience in-transit, passing at a speed outside of your control. You cannot contemplatively pause, you need to reach and crane when given the chance. Everything is set anew standing inside, or passing outside, or obscured by, or moving through a Grosse painting. A seemingly open area unfurls and architectural space is now set not as *what is* but rather as *what if?*

A NON-HUMAN BEING PAINTING

Douglas Ashford

The idea of "feeling into" another person, or occupying an object that one previously understood as outside the self, today seems pivotal to how abstraction might be understood as an aesthetic experience that could re-define society. Its theorization may be partially found in the formation of an expressive psychology, first proposed by the 19th century philosopher Theodor Lipps and then applied by the art historian Wilhelm Worringer in his essay "Abstraction and Empathy" (1907). In this work, Worringer distinguished two formations of art from prehistory to the Enlightenment, and placed them in opposition: naturalistic modes that sought to imitate the world, developed largely through rationalist European frameworks; and abstract modes that transcended mere recapitulations of the world, associated more broadly with the spiritualism of Egyptian art, Eastern mysticism, and Islamic decoration. Through these schemata he outlined different psychological engagements created by the human encounter with art: mimetic works generated empathy, a newly theorized emotional response of self-projection; abstraction opened a space of larger potential. Where empathic experiences of beauty are volumetric and accepting, abstract experiences are flat and insist we project into other models. Empathy is a solitary position; abstracting is collective, pushing identification outside the perceptible world.

When Worringer attached this concept of empathy (literally translated as "feeling into" from the German *Einfühlung*) to classical art and naturalism, he was proposing that what we do when we "feel into" an experience of the world also reinforces our distance from it. If the opposite to being "in" something is being "out," he asked that in considering abstraction we decline the self that displaces others by transferring ourselves into them, and instead turn away to face something else: the anxiety that the world's otherness produces. Today this seems equivalent to viewing oneself through a variety of bodies and positions, looking through another's eyes across vistas, toward this or that event, or even inwards.

Capable of presenting humanity outside identification, beyond the other we predict in ourselves, Worringer felt we needed abstraction in order to see the external world as changeable. Things outside us, he implied, need to be redrawn to overcome our anxiety in their presence—rediscovered in collective experience and individual perception. But what is abstraction "showing" that is beyond depiction? And if it is abstract, a term suggesting withdrawal, from what does it remove itself? Perhaps the answer would be that in withdrawal we actually do represent ourselves through abstraction, just not through self-identification. What would it mean if a person could be hypostatized beyond facing the image of another person—or least any one person? Nonspecific and removed, abstraction is often understood as a purposefully limited relation between humans and their ideas that opens richer, multiple readings. It is as if abstract imagination seeks to allow

something lost, or something too big to see at once, to creep into our detail vision, and when we see differently, we feel differently. We can understand more when looking through the loss that abstraction removes. To emphasize this, I modified and reorganized a quote from Worringer, constructed from different translations, as a work of my own:

> The tendency to abstraction is the result of a great inner conflict between man and his surroundings, a feeling of anxiety that can be considered the root of artistic creation. With the psychological fear of space before the vast, incoherent, bewildering world of phenomena, the case of every human is similar. The rationalistic development of mankind represses that instinctive anxiety which results from the lost state of being in the world. The possibility of happiness, which is sought in art, does not only consist of immersing themselves in the things of the external world, in self-enjoyment, but in freeing things from that world's arbitrariness and apparent contingency, immortalizing them by approximation into abstract forms, and in this way finding a resting place for the flight of phenomena. The strongest impulse might be, as it were, to tear the external object out of the context of nature, out of the endless interplay of existence, to purify it of all dependence on life, all arbitrariness, to make it stable and necessary.

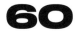

Worringer's treatment of early modernist abstraction can be affiliated with the contemporary context of sociality in art practice: an abstraction not fully oppositional to empathy, but rather a modality for remaking the possibility of "feeling into" others. That is, an anti-naturalistic identification beyond accepted humanistic recognitions; a vision that could produce a sense of humanity beyond, and in reaction to, the definitions of what a society might look like, and how the members of that society might relate to each other. One thing that becomes increasingly clear is that abstract imagining of social experience enables our political imagination. Re-ordering the arbitrariness of the world necessitates a turning away and a refusal of both nature and the naturalizing effect of power, offering a betrayal of the regimentation of the everyday. This creates a personal opportunity for perversion through the denial of the accepted and enforced terms for human empathy. A rationalizing culture always insists on our "good choices." We are told that our decisions to not work with the agendas or expectations of the built society show us to be lazy, our pursuit of love instead of reproduction to be foolish and romantic, our desires and appetites to betray our sense of practicality. But instead how can we have both the love that accompanies empathy, and the distance and comfort that abstraction delimits? How about a rupture with the things that stabilize us? How about turning us away from being rational participants of the world and pushing us towards a world that has not yet existed? Like Worringer's abstraction, desire, appetite, and affection free us from the arbitrariness and contingency of the outer world, offering a proviso for reformation.

61

Accordingly, in an abstract painting, our projections de-specify, and transcend the falsely humanizing contours defined by a depiction of the world, itself a product of media and the state. In this fluidity, our disarrangement implores us to find new relations with each other, new ways of organizing, of being *with* designed experience. And this is a very contemporary question: If abstraction could spill out onto the floor, into the street, partially covering the world, as Katharina Grosse's *psychylustro* does, could abstract models shift what the media and state produces in us? Could it alter our relation to each other? Coming at a time when the false optimism of site-specific art can be increasingly seen as part and parcel of the debt-ridden development of a twenty-firstt century city that makes itself visible to all but available to only a few, these paintings reject the humanizing effect of art in public monumentality— seemingly a contradiction. The unspecific form and unequivocally strident color of *psychylustro* proposes that realities of power might be overcome through as simple an act as painting over them. Recoloring the specificities of location allows a viewer to propose, at least abstractly, that anyplace can become my place, or even better, that all places could become our place. *psychylustro* declares in public that forms can be produced outside of known references, that we can invent these forms outside of the existing templates of power, negotiation, and languages already built, that we can frame a third position, structured only by the abstract dis-arranged feelings made from each other and with each other. Even more so as it arrives at

a superhuman scale, wherein multiple bodies are needed to craft its marks, combined and recombined to cover the breadth of urban subjection. By standing in for the search for place in a world increasingly without location, *psychylustro*, seen through the window of a passing train, undermines the myth of specificity even further. Is this then an even more complete denial of agency in the modern city, acting like so much of its other cultural capital, reinforcing the erasure of place, identity, and agency? I think not. As hard as it sounds, or as inhuman, *psychylustro* asks that we consider what it would be like to refuse to reproduce the world as it is and instead to produce just a shape, something always irregular and fluctuating: an abstraction. In a world that has lost its placeness to economic speculation, such a gesture is full of complex assumptions, and may appear quite unprogressive, even violent. But also, I would like to suggest, spilling with hope. It was Worringer's expectations that form alone could allow a subject to see beyond the capricious organization of nature. Today this is an affecting proposal for the politics of real life: that aesthetic invention could evince life's practical dilemmas and organizations as a dream we are working through, a dream meant to be recolored and seen beyond.

In such a dream, I would want to understand an art that demands the disordering of the world's restrictions; an art that claims a position of reversal or of turning around: away from the rationalization of everyday life and preconceived progress, away from desire's contemporary confinement into commodity and violence. This may seem reactionary, like turning away from the future, but in fact it is only a turning away from the false certainty of progress.

63

Leaving aside humanism's progress is a little scary because in so doing we are leaving aside notions of linear time, the divisions of space and objects created over time, or the singularities of identity that progress has so far defined. Outside of the cities and identities formed by this supposed progress, I can imagine all kinds of possibilities. I could become inappropriately joined to those not related to me, together we could adopt histories not our own, obsess together in an excessive refusal to reproduce the present, and more simply, just forget what we are supposed to do. Finding uses for a self that will no longer contain a rationalized future is physically felt in the body, and sometimes demands that the body be restylized in abstract thought or form—miniaturized to be free and overlooked, deformed to collect new fantasies of use and agency, monstrously over-scaled. And although this re-stylization might feel akin to deformation or death, it is useful to life in its requirement that we turn away from the world that can't accept the full implications of our mind or the real differences of our bodies. It is probably why trying to live beyond rationality puts us—our minds and bodies—on the verge of insanity. Such a self may be the real addressee of an abstract work of art: a strange passerby, seeing the spilled archive of the city, exposed and helplessly facing the artwork's request to be a non-human being.

This essay extracts portions of "Abstraction and Empathy," published originally in *Writings and Conversation by Doug Ashford*, Grazer Kunstverein and Mousse Publishing, 2013.

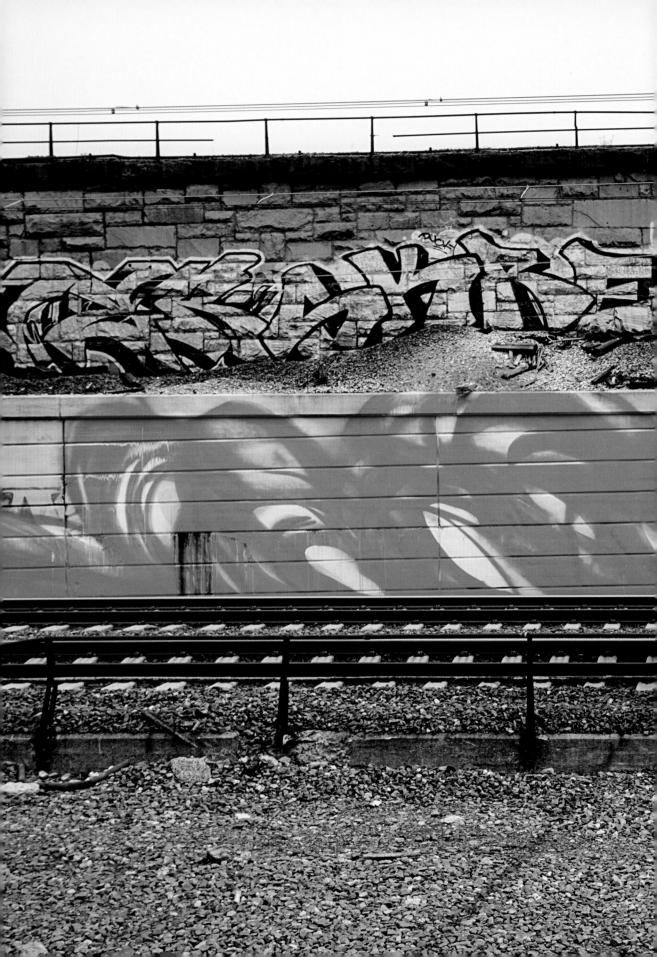

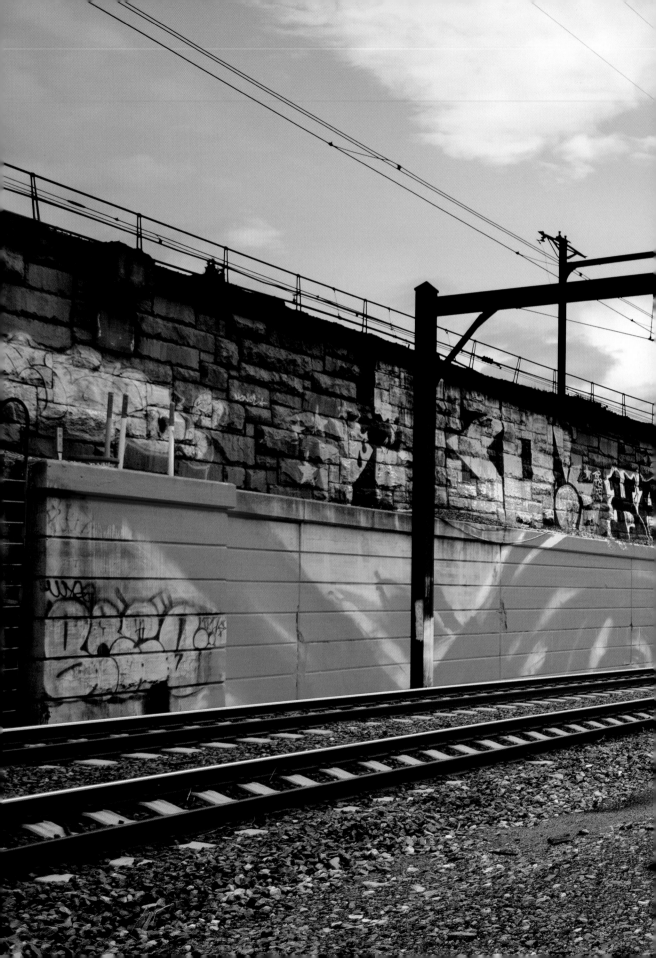

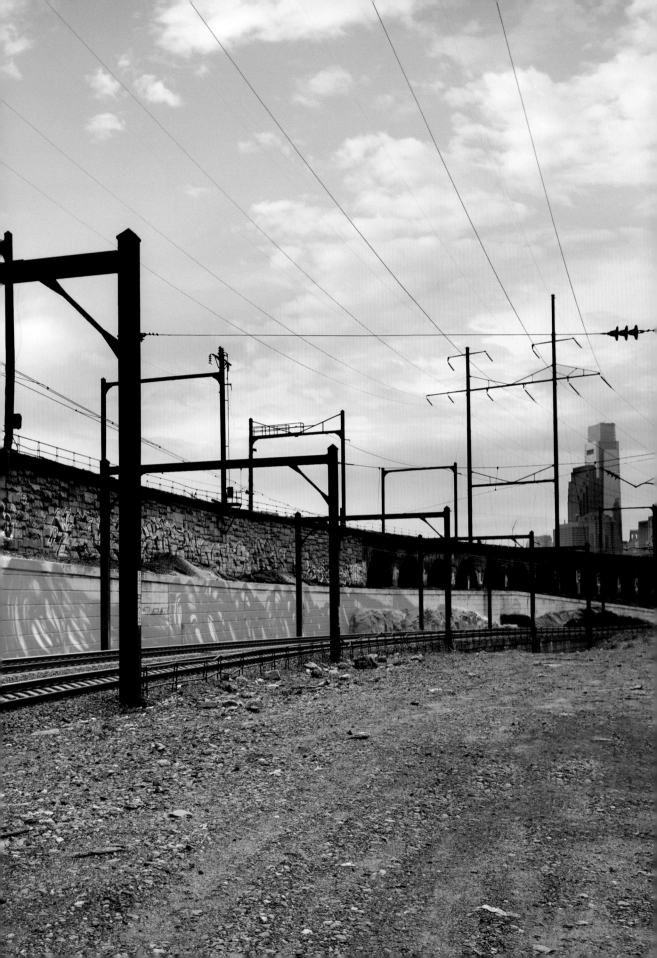

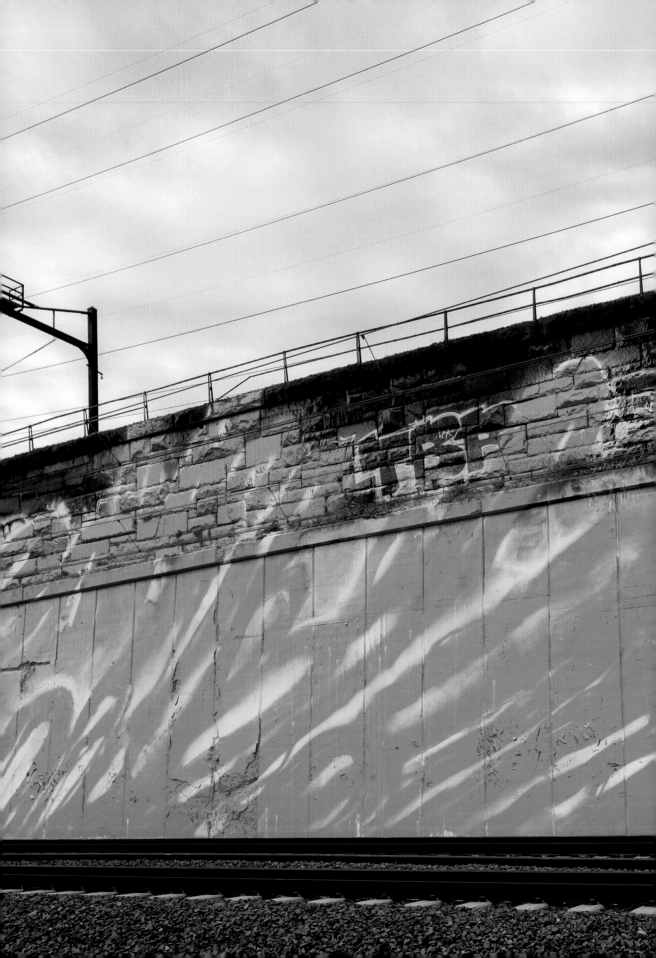

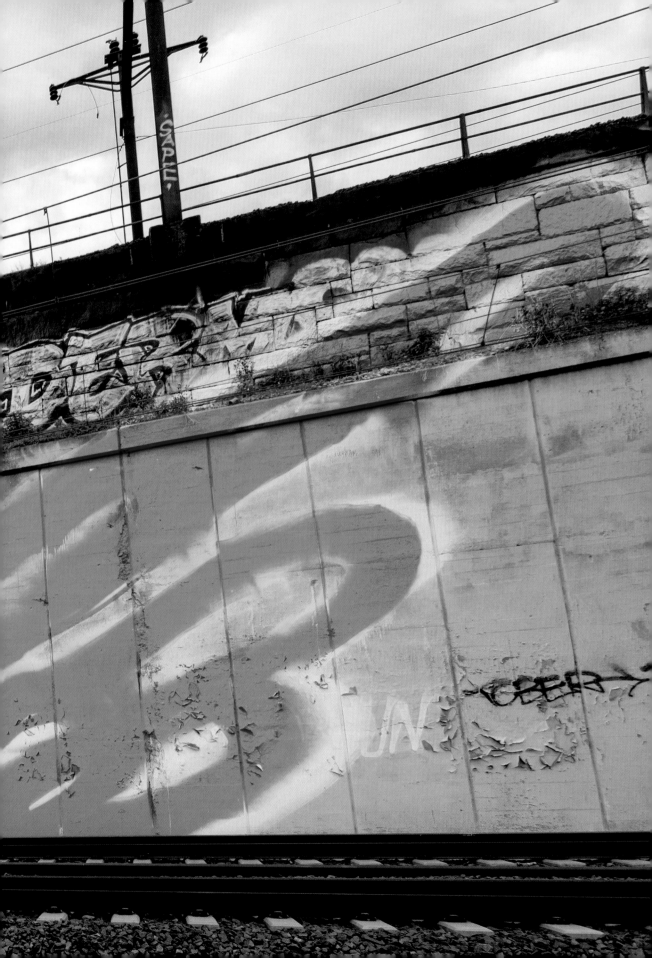

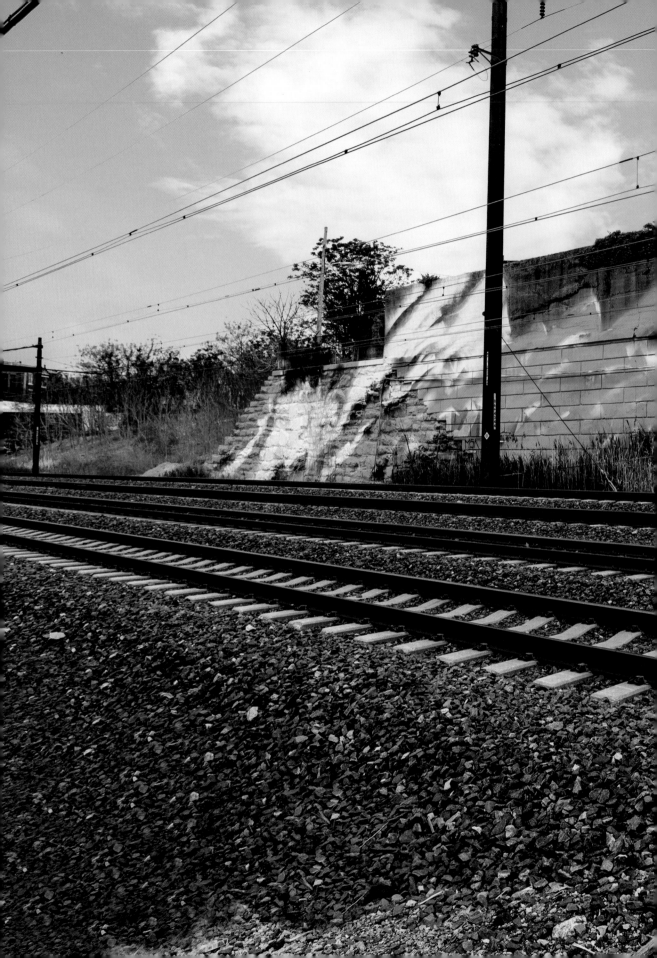

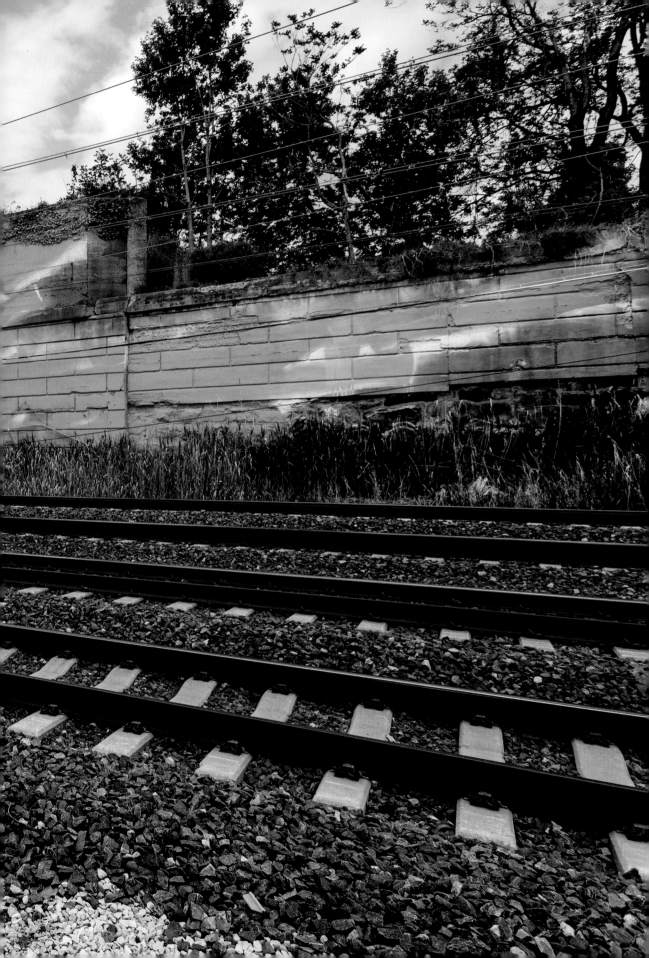

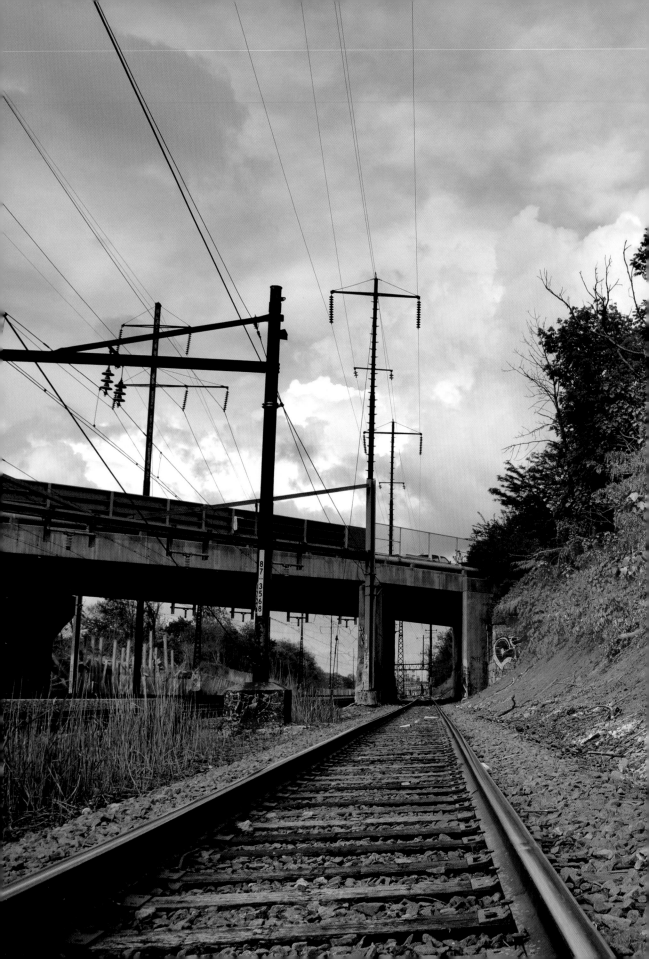

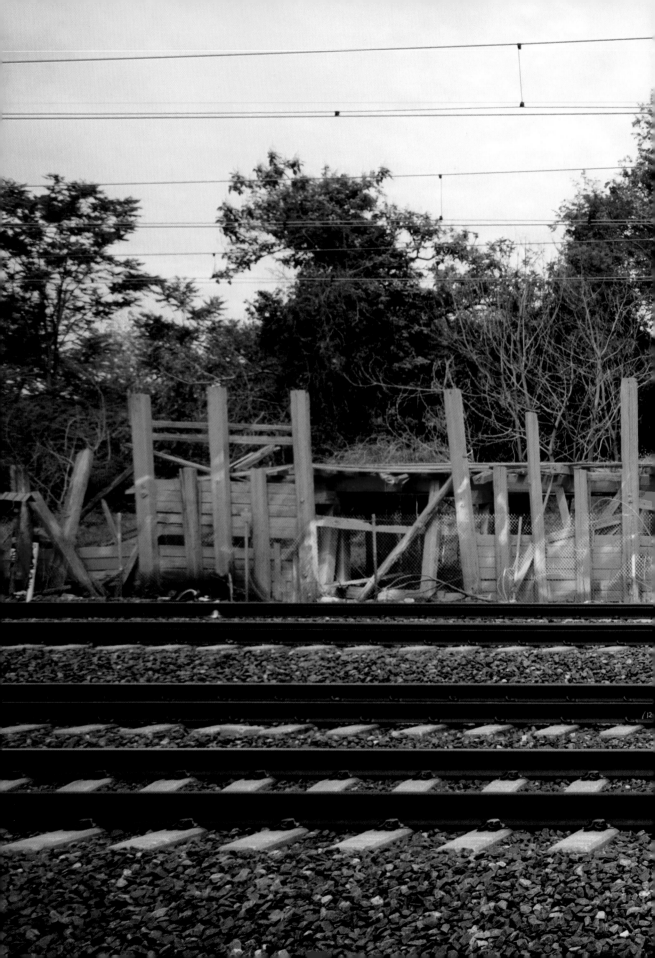

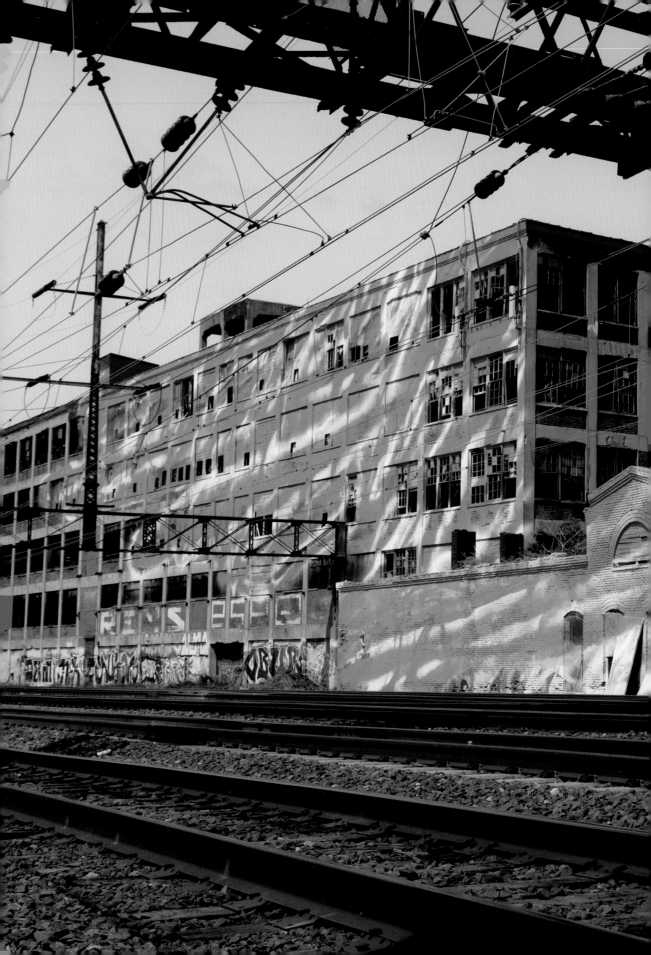

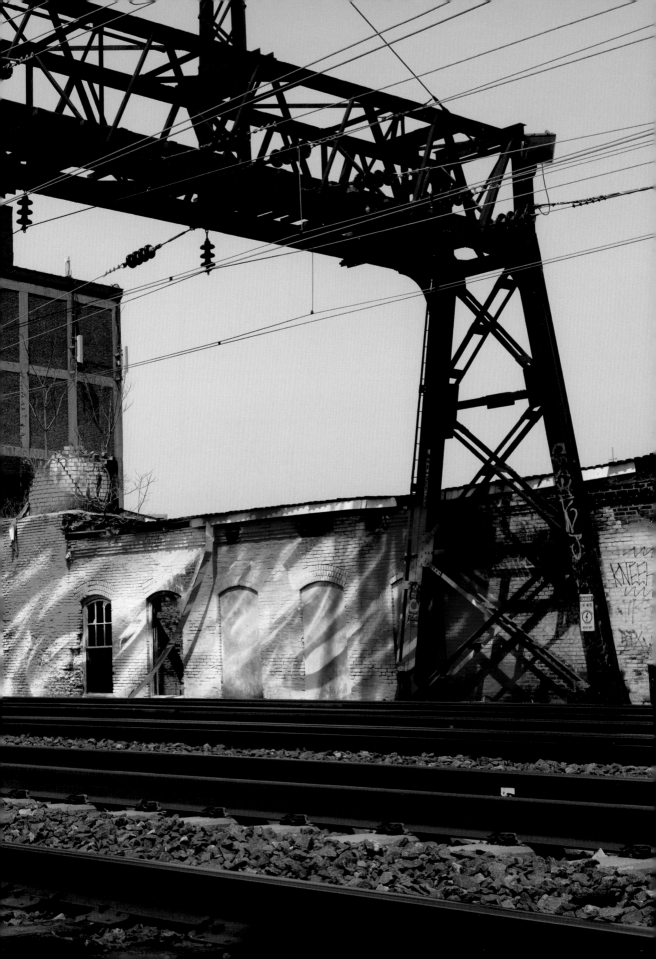

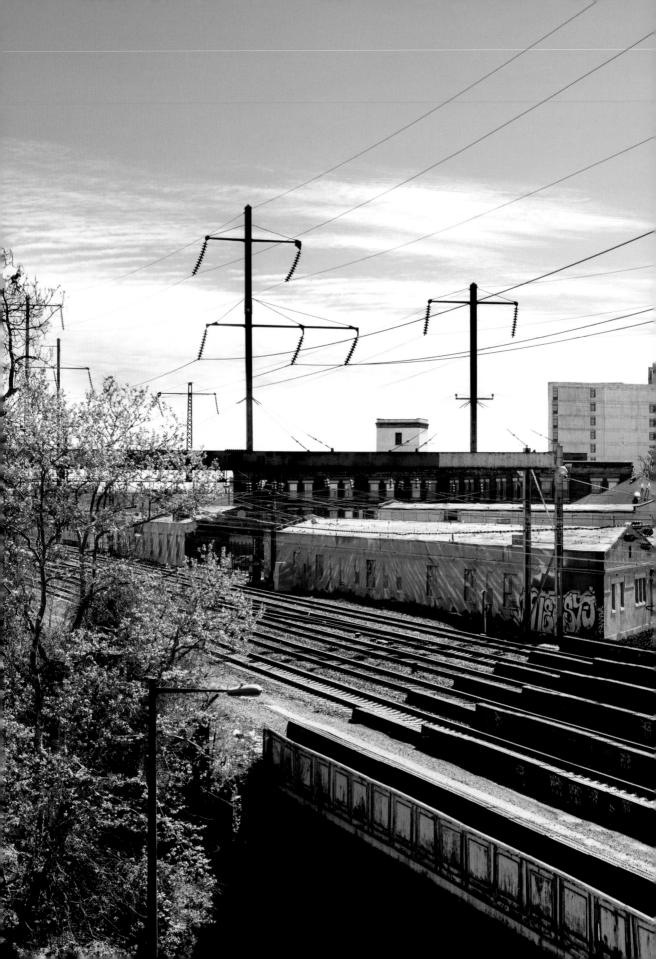

THE QUICK AND THE SLOW

Daniel Marcus

In first narrative accounts of rail travel, the breathtaking pace of steam trains—some twenty to thirty miles per hour—elicited as much terror as wonder prompting one observer to note, "[I]t is impossible to divest yourself of the notion of instant death to all upon the least accident happening."[1] Rail passengers not only feared accidents and crime en route, they also considered the phenomenology of rail travel to be a danger in its own right. An 1884 medical pamphlet lists the following pathologies of motorized perception:

> There is pulling at the eyeballs on looking out of the window; a jarring noise, the compound of continuous noise of wheels, and this conducted into the framework of the compartment; with the obbligato of whistle and of the brake dashing in occasionally, and always carrying some element of annoyance, surprise or shock; there is the swaying of the train from side to side, or the jolting over uneven rails and ill-adjusted points; and the general effect of these upon the temper, the muscles, and the moral nature [...] There are 'impressions' that are made, and that unavoidably, by the very conditions of the journey; and they involve fatigue. The eyes are strained, the ears are dinned, the

1 John Gore, ed., *The Creevy Papers* (New York: B.T. Batsford, Ltd., 1963), 256; quoted in Wolfgang Schivelbusch, *The Railway Journey: The Industrialization of Time and Space in the 19th Century* (Berkeley and Los Angeles: The University of California Press, 1986), 15.

muscles are jostled hither and thither, and the nerves are worried by the attempt to maintain order, and so comes weariness.[2]

Initially, the landscape perceived through the compartment window was a source of pain, not pleasure. "Pulling at the eyeballs," it tested the viewer's powers of attention, overtaxing the eye with ceaseless "impressions," a term that would have been understood literally, as the pressing or stamping of light on the retina. However, commentators soon began to discover in this optical barrage a source of enjoyment, and even a new genre of visual experience which historian Wolfgang Schivelbusch calls "panoramic vision." The railway spectator no longer struggled to perceive individual elements of the passing scenery; instead, she grew to savor the commingling of formerly discrete entities in an indistinctive flow. As one nineteenth-century traveler enthused, "Nothing by the way [of the train] requires study, or demands meditation, and though objects immediately at hand seem tearing wildly by, yet the distant fields and scattered trees, are not so bent on eluding observation, but dwell long enough in the eye to leave their undying impression."[3] Like a filmstrip, the railroad synthesized distinct spaces and environments into a continuous unity, all threaded together by the horizon's fluid line. Although objects in the foreground were beyond contemplation, flashing by too quickly to be seen, the spectator could easily follow the changing features of the background, which became a sort of meta- or second-order landscape—a whole distinct from its parts, and enjoyable as such.

2 Russell Reynolds, "Travelling: Its Influence on Health," in *The Book of Health,* ed. Malcolm Morris (London, Paris, and New York: Cassell, 1884), 581; quoted in Schivelbusch, *The Railway Journey: The Industrialization of Time and Space in the 19th Century,* 118.

3 Matthew E. Ward, *English Items; or, Microcosmic Views of England and Englishmen,* (New York: D. Appleton & Co., 1853), 47–8; quoted in Schivelbusch, *The Railway Journey: The Industrialization of Time and Space in the 19th Century,* 60.

Material evidence of "panoramic vision" can be traced back to nineteenth-century popular culture, which brimmed with simulated versions of high-speed spectacle. When, in 1896, the Lumière Brothers captured on film the final moments of a train's journey back to station, they unwittingly pioneered a new genre of cinema. Although the earliest experiments in railway cinematography favored the panoramic format, moviegoers came to prefer the so-called "phantom ride": film shot from the conductor's perspective, so that the camera appeared to be drifting autonomously along the tracks, unencumbered by its technological apparatus.[4] Prior to the advent of film, the train journey had been a popular theme of painted panoramas as well: For example, in 1834, visitors to the London *Padorama* could view a 10,000 square-foot strip of painted scenery, offering the view as seen from the newly built Liverpool and Manchester line.[5]

Schivelbusch is keen to emphasize the generational assimilation of railway phenomenology: By his reckoning, those passengers who grew up traveling by train, or who experienced rail travel via popular simulations, had been able to enjoy panoramically what their predecessors had not. Yet in their details, the artifacts of railway culture point to the difficulty, and even impossibility, of fully synthesizing a new landscape from the old. For instance, in the brochure accompanying the 1834 *Padorama* exhibition, we discover that much of the scenery—"the dull portions of the road"— was omitted by the artists; for "[t]o have given an uninterrupted continuous representation would have occupied too great a space, and would besides have been uninteresting to the Public."[6] No such aesthetic alteration

4 See Patrick Keiller, "Phantom Rides: The Railway and Early Film," in *The Railway and Modernity: Time, Space, and the Machine Ensemble,* eds. Matthew Beaumont and Michael Freeman (Bern: Peter Lang, 2007), 70–4. For a related discussion of the cinema/railway dyad, see Tom Gunning, "Landscape and the Fantasy of Moving Pictures: Early Cinema's Phantom Rides," in *Cinema and Landscape,* eds. Graeme Harper and Jonathan R. Rayner, (Chicago: Intellect, The University of Chicago Press, 2010).

5 Stephan Oetterman, *The Panorama: History of a Mass Medium* (New York: Zone Books, 1997, cited in Keiller, op. cit., 69–70.

6 *Descriptive catalogue of the Padorama of the Manchester and Liverpool Rail-road,… now exhibiting at Baker Street, etc.* (London: Liverpool and Manchester Railway, 1834), 8.

83

was possible in real life, however: The in-person journey between Manchester and Liverpool would have been far duller than its simulation. Likewise, in the Lumière Brothers' *Panorama of a Train Arriving at Aix-les-Bains* (1896), the abrupt succession of objects and spaces far and near, from a river to a bridge to an advertisement to the façade of an apartment building, interrupts and fragments the panoramic view; again and again, the eye is drawn to the fleeting foreground. Both examples suggest that the panorama was first and foremost a *curated* landscape, with occasional picturesque views punctuating an otherwise null field of vision. Inevitably, some portion of the landscape—indeed, the vast majority—ends up lost to view, and the passenger has no choice but to take this in stride, experiencing the lacuna not as privation, but as a kind of plenitude.

 The railroad altered the ecology of the visible world, not only for passengers, but for pedestrians as well. Whereas the railway passenger loses sight of the foreground, the reverse is true of the pedestrian, for whom the *background*— where the immediate sphere of vision meets with, and is qualified by the distant line of horizon—is simultaneously stolen and multiplied by the expansion of transportation infrastructure (including utilities such as electricity, water, telephony, etc.). Stolen, insofar as the layering of speedways blocks access to the horizon, rendering it unapproachable on foot; multiplied, since this flow-space of high-speed traffic effectively replicates the horizon's signature effect: its horizontality. For the pedestrian, even the least trafficked roads and railways bring the far edge of the earth terrifyingly close, buttressed by just a few feet of sidewalk or gravel. As

paved roads and power lines come to dominate the human environment, the background of the pedestrian world becomes increasingly isolated, to the point that the distance between near and far is no longer mediated. The burden of optical concentration falls less to the quick than to the slow, those who, foot-bound, are compelled to see things that were never meant to be looked at in any detail: tracks, roads, telephone wires, retaining walls, highway underpasses, etc. For many subjects of the contemporary metropolis, the pathways of high-speed transportation amount to a visual blind spot, offering little other information than the raw fact of an *elsewhere* from which the near world has been excluded.[7]

Pictorial art plays an insurgent role in this partitioning of the quick from the slow. Graffiti writing, which evolved in close relation to the decay of urban transportation systems, is more than a mere countercultural expression: In the tags, throw-ups, and full-scale pieces that make up the lexicon of contemporary graffiti, the components of abstract painting and modernist typography are deployed in such a way as to widen the rift—technological as well as economic— separating passengers from the landscape. Politically, graffiti intervenes on behalf of the pedestrian class, serving an implicit warning to passengers: Unless mobility is universal, it is only a privilege, not a source of freedom. Modernism once made a similar claim: "Follow me, comrade aviators!" urged Kasimir Malevich in 1919, as the still-nascent Russian Revolution lurched toward full mobilization, proffering mass liberation in terms of mass *acceleration*.[8] By the end of the century, however, the slogans had changed: In New York City of the 1980s, the avant-garde imperative was to

7 For a synthesis of relevant statistical research on mobility and employment since 1960, see Susan Hanson, "The Context of Urban Travel: Concepts and Recent Trends," in Susan Hanson and Genevieve Giuliano, eds., *The Geography of Urban Transportation (Third Edition),* (New York: The Guilford Press, 2004).

8 This discussion of the politics of speed owes much to the work of Paul Virilio; see in particular *Speed and Politics,* trans. Mark Polizzotti (Los Angeles: Semiotexte, 2006); originally published as *Vitesse et Politique* (Paris: Édition Galilée, 1977). For a compendium of more recent debates on acceleration and modernity, see Robin Mackay and Armen Avanessian, eds., *#ACCELERATE: The Accelerationist Reader,* (London: Urbanomic, 2014).

"bomb the system" and to "destroy all lines," waging a war of painted pseudonyms that promised, at least in theory, to force the mass-transit system to a halt.[9] A continuous thread connects Malevich's moment with the deindustrialized modernity of the late twentieth century: Then as now, capitalism and mobility are inseparable, although the growth of the former has done little to universalize the latter. Whereas industrialization put engines at the service of the masses, deindustrialization appears to have reneged on this promise; in the decentralized and increasingly suburban landscape of post-industrial labor, the rise of Uber, Lyft, and similar travesties of "shared" mobility has downgraded (but up-marketed) speed from communal resource to private commodity. As demand for transportation rises, mobility seems poised to become a privilege rather than a right—a shift epitomized by Elon Musk's proposed "hyperloop" hydraulic tunnel, the ultimate vision of a post-pedestrian world.

Where should *psychylustro* be situated in this matrix of speed and vision? In a press statement, Grosse speaks of *psychylustro* in terms not far removed from the rhetoric of urban beautification, claiming that painting enables her to "get close to people, to stir up a sense of life experience and heighten their sense of presence."[10] It would be reasonable to wonder whether these ambitions amount to beautification—visual neurasthenia for the world-weary commuter. If not this, then what kind of "life experience" does *psychylustro* afford?

For my part, I doubt that we can take any claims about beauty at face value. There are few conventional definitions of the beautiful that would accommodate Grosse's

9 This was an ambiguous gesture: "bombers" of the Manhattan subway system were effectively attacking a venerable proletarian institution (rather than, say, defacing private taxis and limousines), yet their gesture was crucial in rallying attention to the defunding of public infrastructure in a city struggling to recover from bankruptcy.

10 Katharina Grosse, quoted in the Mural Arts press release for *psychylustro*. http://muralarts.org/katharinagrosse.

installation. Her choice of colors—a garish palette of fluorescent green, pink, and orange, closer to the stuff of Ghostbusters than to Matisse or Monet—seems calculated to startle the eye, if not to offend it outright. Despite precautions that its component materials will degrade safely and responsibly, *psychylustro* calls to mind scenes of environmental catastrophe or chemical warfare without conforming to any clear-cut allegory of decay and reanimation. The work neither beautifies North Philadelphia nor brands it as a disaster area; but what *is* the point then?

To get close to people, to stir up a sense of life experience, to heighten the viewer's sense of presence— these objectives could easily have been lifted from the instruction manual of the 1834 *Padorama*. As it turns out, however, the phrase "to get close" means something quite specific, if counterintuitive, in Grosse's lexicon. Closeness usually implies proximity, but for Grosse, the ultimate form of closeness is *theatrical*: not physical nearness, but the projection of attention beyond the bounds of the self, into the realm of someone else's subjectivity. To become truly close with someone, she argues, we must be able to believe that we *are* that person—as Grosse puts it, "Watching life on stage gets you away from identifying with your social persona. When I understood how to *not* identify with my work I felt very free and powerful."[11] Defined this way, closeness has more to do with communion than contact. This goes for Grosse's method of painting as well, which suppresses the sense of touch in favor of pure, disembodied vision: "I use the space and the surface but I don't touch it, feel it, and fetishize it. I'm quite detached from it because of my mask and protective

11 Katharina Grosse interviewed by Ati Maier, *BOMB Magazine* no. 115 (Spring 2011), http://bombmagazine.org/article/4910/katharina-grosse.

87

clothing. I watch myself doing it. I see the paint hitting the wall in front of me; the implement [i.e. a spray gun] does not obscure it, as with a paintbrush."[12]

Like many modernists—and many more panorama painters—before her, Grosse aligns freedom with vision: To be free, she argues, is to escape the tactile, spatial enclosures of the pedestrian world. Few contemporary city dwellers would disagree with her. As the speed/vision system expands, freedom becomes rewritten in terms of the velocity of self-estrangement: Emancipation, once a category of personal and spatial autonomy, now means liberty *from* the physical here-and-now—not to *be* autonomous, but to *access* the autonomous circuitry of rapid, and even instantaneous, transportation (whether vehicular or electronic). In this sense, *psychylustro* can be interpreted as a test case for the realization, even if only locally and temporarily, of modernism's dream of universal speed, forging a communion of liberated souls from the constituencies of Amtrak and SEPTA.

Optimism, although a strong note, is not *psychylustro*'s only note. Far from bathing the spectator in a continuous experiential landscape, as with the *Padorama*, *psychylustro* punctuates the post-industrial scenery sporadically and unexpectedly. During the eight- to ten-minute trip between 30th Street Station and North Philadelphia, the viewer scans the foreground in search of the next painted site, until suddenly, without transition, the color field flashes into view. Throughout the journey, various species of graffiti compete for the rider's attention, from serial tags to unique wall-sized pieces, some made by locals,

12 Katharina Grosse interviewed by Louise Neri, "Painting in the Expanded Field," in *Antipodes: Inside the White Cube,* (London: White Cube, 2003).

88

others by regional notables like SKREW, NEKST, and SIRE. Although Grosse makes a point of sharing the rail corridor with graffiti writers, she expresses the difference between her use of spray paint and theirs in no uncertain terms:

> I don't mark areas … signifying that [this or that place is] mine. Graffiti is actually marking possessions, making claims on certain areas, saying, "If you go into that area you are actually trespassing," whereas my work is very much about the opposite: about inviting people to trespass, and the freedom that is implied with that activity.[13]

This passage might suggest a disagreement between Grosse and the writer community, yet I am inclined to group them together, as two halves of a divided whole. Graffiti cuts short modernism's dream of visual trespass, summoning the spectator back to the here-and-now, and to the dismal business of possession and dispossession. Nevertheless, Grosse insists on the dream's necessity: Although painting cannot remove the partition between *here* and *there* (the pedestrian's world versus the circuitry of the speed-enhanced), it can at least make this partition visible, showing us the limits to freedom—urging us onward. In this sense, *psychylustro* operates parallel with the Lumières' panoramic train films, but perpendicular to the *Padorama*: Rather than erase the image of the slow world, synthesizing passenger and landscape by fiat, Grosse puts the divided halves side by side, letting the broken be broken, letting us see it that way.

13 Video interview with Katharina Grosse on the occasion of her exhibition, *Hello Little Butterfly I Love You What's Your Name?* at ARKEN Museum of Modern Art, Copenhagen, Denmark. https://www.youtube.com/watch?v=rJkSs5EQ7nk. Uploaded December 10, 2009.

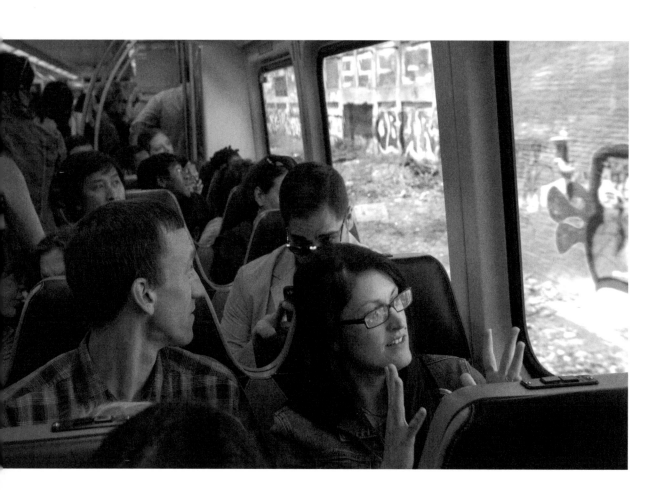

AFTERWORD

Jane Golden

Over the last five years at the City of Philadelphia Mural Arts Program, where I am the Executive Director, we have reimagined our work in bigger, bolder ways without losing sight of our social mission. We have challenged ourselves to investigate new methods of production and to redefine the scope of our civic engagement. And through large multi-year collaborations and public art projects like *psychylustro,* we take on difficult and complex issues while bringing together a multitude of stakeholders, communities, and organizations. With *psychylustro,* our work is made possible by the nearly 34,000 rail commuters who travel daily by Amtrak, SEPTA, and NJ Transit along the five-mile stretch of Northeast Rail Corridor between Philadelphia's 30th Street and North Philadelphia stations; the cooperation of three railroads—Amtrak, CSX, and Conrail—who gave us permission and access to paint their property; private building owners along the rail corridor; Glenwood Green Acres, a community garden just south of North Philadelphia Station; an amazing team of artists from Berlin and Philadelphia; and incredibly generous and visionary funders of the arts, foremost among them The Pew Center for Arts & Heritage, National Endowment for the Arts, John S. and James L. Knight Foundation, PTS Foundation, and The Fierce Advocacy Fund.

During this time we have focused our attention on gateway projects. What do people see when they leave and enter Philadelphia? Part of this thinking included the dream of creating a linear gallery along this corridor, with work that changes from year to year. Although that has yet to come to fruition, when looking for a site for Katharina this space now seemed perfect for her work. For years people have discussed this corridor, what to do, where to go with it. The multitude of owners, the decay of the structures, the rubble and blight, all of it makes the area feel haunted, otherworldly, almost impossible to change. But transforming spaces is precisely what Katharina's work does. The idea of creating something poetic and episodic, something that resulted in an explosion of color, excited us. The sheer juxtaposition of artist meeting site, and color meeting the world was exhilarating, and and would allow us to explore new ways of painting in public space. We wanted to choreograph an experience that moved viewers through time and space; we wanted to illuminate the rubble, the wild eruptions of nature; and we wanted to highlight the contradictions of decay and rebirth in this strange setting. We love the fact that it is seen by people in motion, people often locked in their day to day thoughts. As the curator Elizabeth Thomas says, "the project aims to frame viewers' railway journeys and intensify the experience of their surroundings." But there is something else. We want people to see what we see. We see the deterioration, but also beauty and history and our city's past and potential for re-imagining the future.

Through each Mural Arts project, we want to celebrate collaboration, imagination, and innovation. As we

transform space, we want to transform community expectations, stimulate dialogue, and enrich the discourse. We hope that this project connects people to art, takes them out of their daily routine, taps into their imagination, enriches their lives, and perhaps, just perhaps, stimulates a renewed dialogue about the industrial corridor and what it means to us in the twenty-first century. Jeremy Nowak, a consultant for cities, says "mural making is a process that builds social capital and creates opportunities, sometimes small and subtle, sometimes big and dramatic—for our engagement crosses boundaries between public, private, and the civic sectors." And that is what this project did.

But of course we know that this work will not restore or change this corridor. We know all too well that change is incremental and what you hope for with projects as complex as *psychylustro* is that they will be catalytic in some way. The creative and participatory qualities in our work can open windows of opportunity through which we can see other possibilities. That is our deep hope—that our work will keep the windows open long enough to promote other acts of self-renewal and community discovery.

I have heard a range of opinions about *psychylustro* and I find it stirring, because I believe art creates that range. It creates conversation, discourse, and dialogue where before there was silence. Last night I got home and my husband had just taken the train from New York. He had sat next to someone who went to Maryland Institute College of Art (MICA), and she became quite excited when she heard that his wife was connected to Mural Arts. She said she loved the project, she googled Katharina, she talked of Katharina's

boldness. She loves the wall that faces I-76 best. Others say they love the work that is more textural, that falls over brush and metal and rock. Some say they are baffled by it and "don't understand" why we did not do a traditional mural. Some graffiti writers and artists are angry and think we are declaring a "war on graffiti," others feel their tags on the corridor were from another era, understand the ephemeral nature of their work, and are happy to see the color. One of our colleagues at MAP hates it; many of them love it and some are in-between. One person compared it to a jolt of caffeine. Some people want more color—they feel short-changed, they feel we have whet their appetite and want more. I like that. It is like reading a beautiful haiku, or a short story, or hearing a very short, inspiring speech. The brevity makes us yearn for more. But then our imagination kicks in and we realize that it is okay that it wasn't long, and that the color is not everywhere, because there is something poetic and wonderful about the bursts showing up in unexpected ways and filling in the blank spaces by ourselves.

94

Katharina Grosse
psychylustro

CURATOR
Elizabeth Thomas

PROJECT DIRECTOR
Judy Hellman

MANAGER,
GROSSE STUDIO
Natalija Martinovic

ASSISTANT ARTISTS,
GROSSE STUDIO
Arne Schreiber
Beate Slansky

ASSISTANT ARTISTS,
PHILADELPHIA
Nathaniel Lee
Erin DeRosa
Malachi Floyd
Diana Gonzalez
Darin Rowland
Thomas Walton

SOUND COLLAGE
Jesse Kudler

PHOTO CREDITS
All photos by Steve Weinik for the
City of Philadelphia Mural Arts
Program. Exceptions:
p.52 left: Photo by Arthur Evans
p.52 top right:
Photo by James Ewing
p.52 bottom right:
Photo by Torben Eskerod,
© Katharina Grosse
and VG Bild-Kunst Bonn, 2014
pp.74/75 by Michael Reali
for the City of Philadelphia Mural
Arts Program
Video stills on pp. 98/99, 102/103,
106/107, 110/111 by Jonathan
Kaufman for the City of Philadelphia
Mural Arts Program

DOUG ASHFORD is an artist, teacher, and writer based in New York. He is Associate Professor at The Cooper Union for The Advancement of Science and Art where he has taught sculpture, design, and interdisciplinary studies since 1989. Ashford's principal visual practice from 1982 to 1996 was the artist's collective *Group Material,* which produced over forty exhibitions and public projects internationally. Since 1996 he has continued to produce paintings, essays, and collaborative projects that engage sociality in artistic form.

ANTHONY ELMS is Associate Curator at the Institute of Contemporary Art, University of Pennsylvania, and is also the Editor of *WhiteWalls* Inc. His writings have appeared in several catalogs and publications, including *Afterall, Art Asia Pacific, Art Papers,* and *May Revue,* among others. He was one of three curators of the 2014 Whitney Biennial.

JANE GOLDEN has been Executive Director of the City of Philadelphia Mural Arts Program for thirty years. Under Golden's direction, the Mural Arts Program has grown from a small city agency into the largest mural program in the United States. She is the co-author of *Philadelphia Murals and the Stories They Tell*, *More Philadelphia Murals*, and *Mural Arts @ 30.* Golden holds a Master of Fine Arts from the Mason Gross School of the Arts at Rutgers University and degrees in Fine Arts and Political Science from Stanford University.

KATHARINA GROSSE
For CV and bibliography please refer to www.katharinagrosse.com.

DANIEL MARCUS is a PhD candidate in the History of Art at the University of California, Berkeley, where he is completing a dissertation on the crisis of modernist landscape in the era of mass automotive transportation, focusing on Henri Matisse, Le Corbusier, and Fernand Léger between 1917–34. He is a frequent contributor to *Artforum,* and his critical writing and essays have appeared in *October, Art in America,* and elsewhere. He is currently the 2013–14 Teaching Fellow in the Histories of Art, Media, and Design at Art Center College of Design (Pasadena).

ELIZABETH THOMAS is the curator of *psychylustro,* and currently developing an independent platform for collaborative public practice informed by her experience developing commissions inside of institutions that considered central questions of research, interdisciplinarity, and political and social engagement. She previously directed the MATRIX program at UC Berkeley Art Museum, after curatorial positions at Carnegie Museum of Art and Walker Art Center. She is presently Senior Lecturer in Curatorial Practice at California College of the Arts, and is also at work on a book of interviews concerning ignorance and knowledge production for SALT, Istanbul.

Presented in cooperation with Amtrak, *psychylustro* was made possible with major support from The Pew Center for Arts & Heritage, and additional generous support from National Endowment for the Arts, John S. and James L. Knight Foundation, The Fierce Advocacy Fund, PTS Foundation, AT&T, Philadelphia Zoo, Joe and Jane Goldblum, David and Helen Pudlin, halfGenius, and The Beneficial Foundation, with support for this publication from the Elizabeth Firestone Graham Foundation. *psychylustro's* media partners were WHYY's NewsWorks.org and Metro Newspaper.

Katharina Grosse's work appears courtesy of Barbara Gross, Munich; Galerie nächst St. Stephan— Rosemarie Schwarzwälder, Vienna; Johann König, Berlin; and Mark Müller, Zurich.

SPECIAL THANKS
Bill Adair
Susanna Lachs Adler
Shaun Baron
Jim Barrett
Carlos Basualdo
Jamie Bischoff
Barry Bond
Maria Bourassa
Sean Buffington
David Burke
Caitlin Butler
Canary Promotion
Senator Robert Casey
David Cell
Shereen Chen
Tom Conway
Martha Cooper
Phil Coyne
Peter Crimmins
Chris Crockett
Rina Cutler
Deliverance Evangelistic Church
Tammy Leigh DeMent
Douglas Demming
Vik Dewan
Allan Espiritu
Eileen Gallagher
Drew Galloway
Stephen Gardner
Judith Gärtner
GDLOFT
Everett Gillison
Glenwood Green Acres
William Goetz
Nancy Goldenberg
Alan Greenberger
Zambia Greene
Nathaniel Hamilton
Leon Hammond
Matt Horan
Carolyn Huckabay
Danelle Hunter
Institute of Contemporary Art, University of Pennsylvania
Thora Jacobson

Amy Johnston
Jonathan Kaufman
Kevin Kernan
Jeffrey Knueppel
Prem Krishnamurthy
Lindsay Lazarski
Robert Lund
Darlene Marcus
Paula Marincola
Randy Mason
Corinne Militello
Carise Mitch
Peter Nesbett
Howard Neukrug
The Honorable Michael A. Nutter, Mayor, City of Philadelphia
Utpal Passi
Pennsylvania Horticultural Society
Alex Peltz
David Perri
Philadelphia Center for Architecture
Philadelphia Museum of Art
Philadelphia Zoo
Michael Reali
Joan M. Reilly
Douglas Respass, Jr.
Vie Ricketts-Dhomas
RJ Rushmore
Chris Satullo
Leslie Scherr
G. Kevin Smith
Ellen Solms
Liz Solms
Gary Steuer
Andrew Stober
Brett Sturm
JT Taylor
Marilyn Jordan Taylor
University of the Arts
Joe Verdi
Keith Warren
Steve Weinik
Megan Wendell
Paul Williams
Erin Wilson
Kenneth Woodson
Stephanie Zirpoli

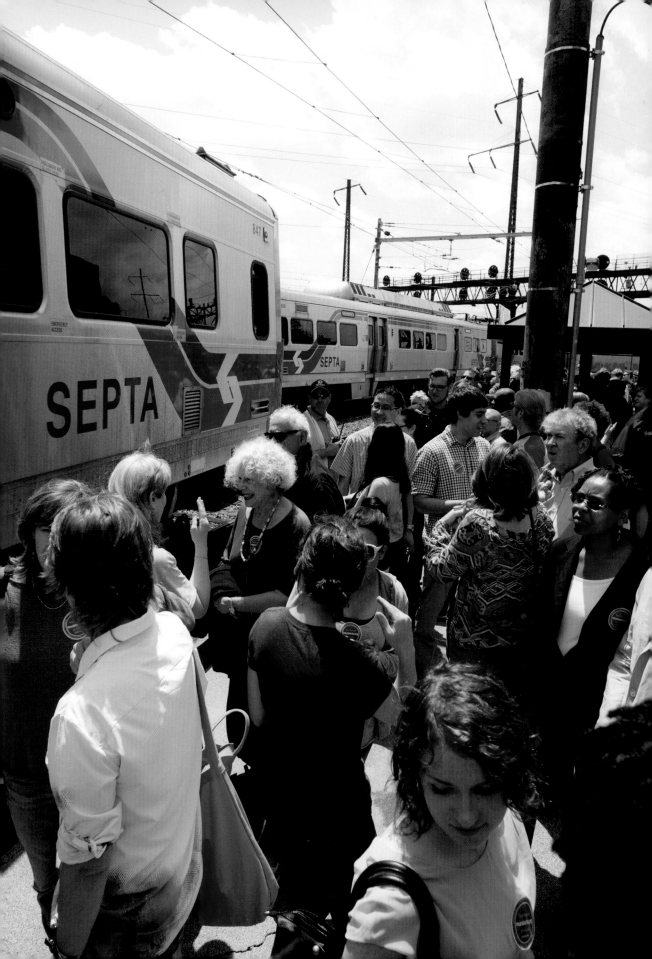

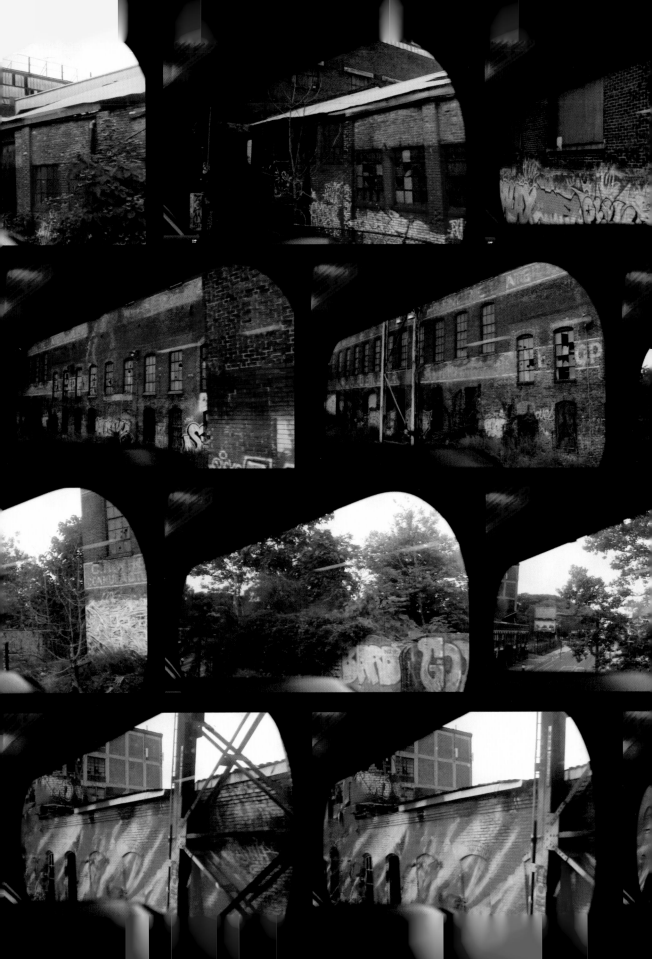

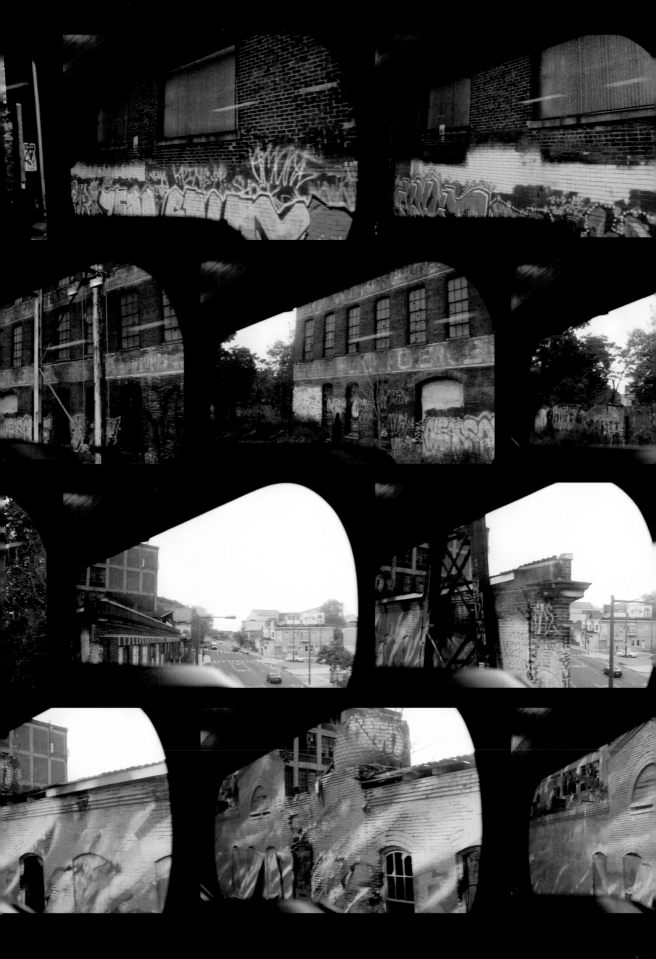

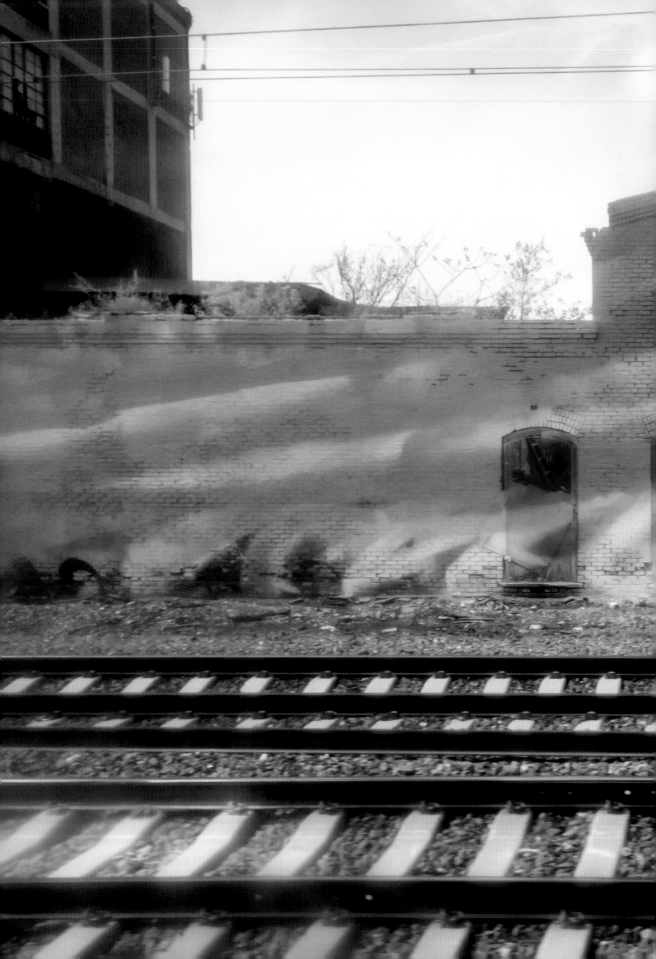

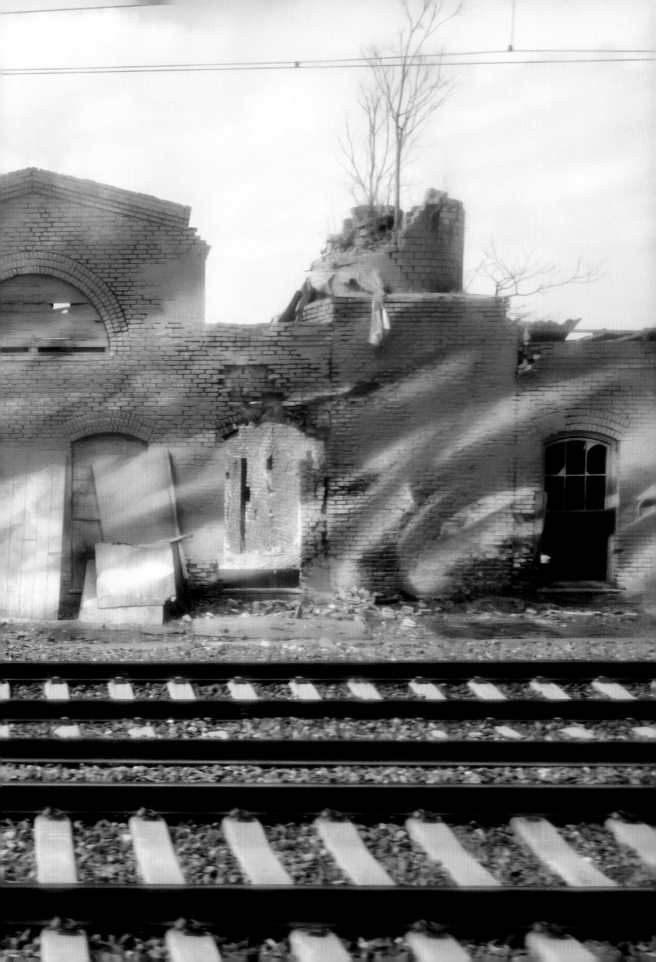

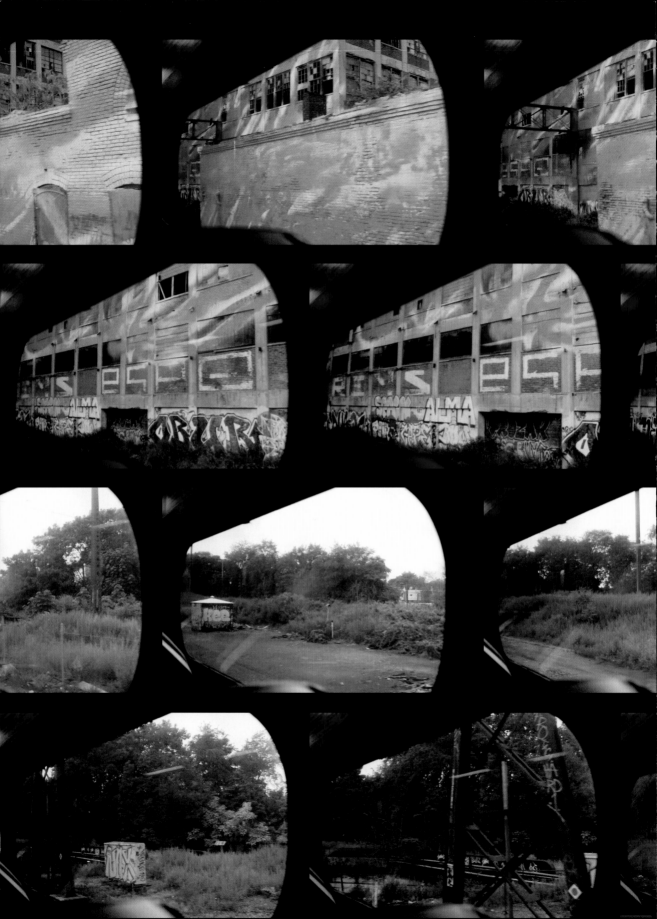

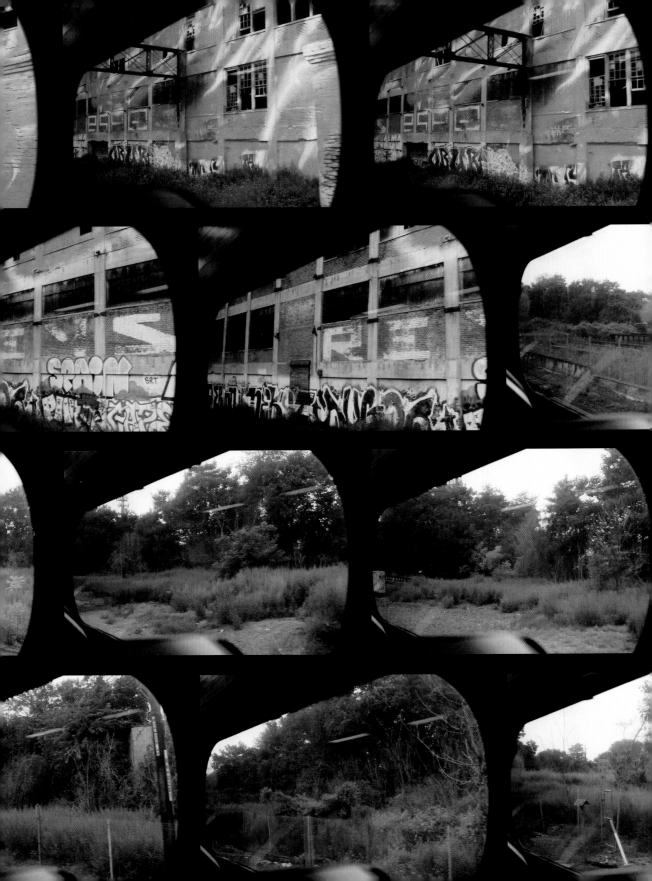

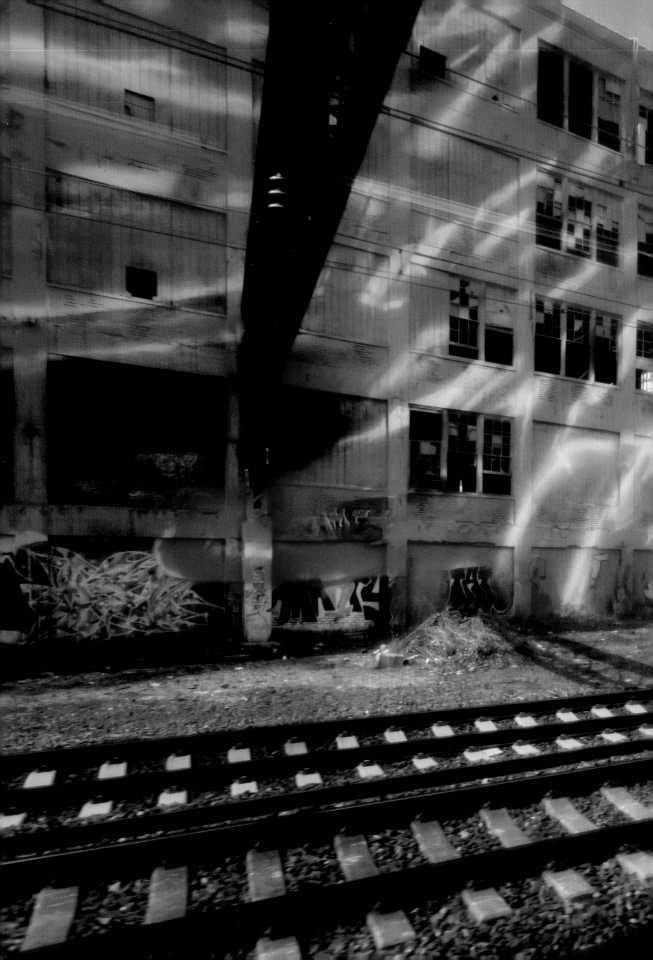

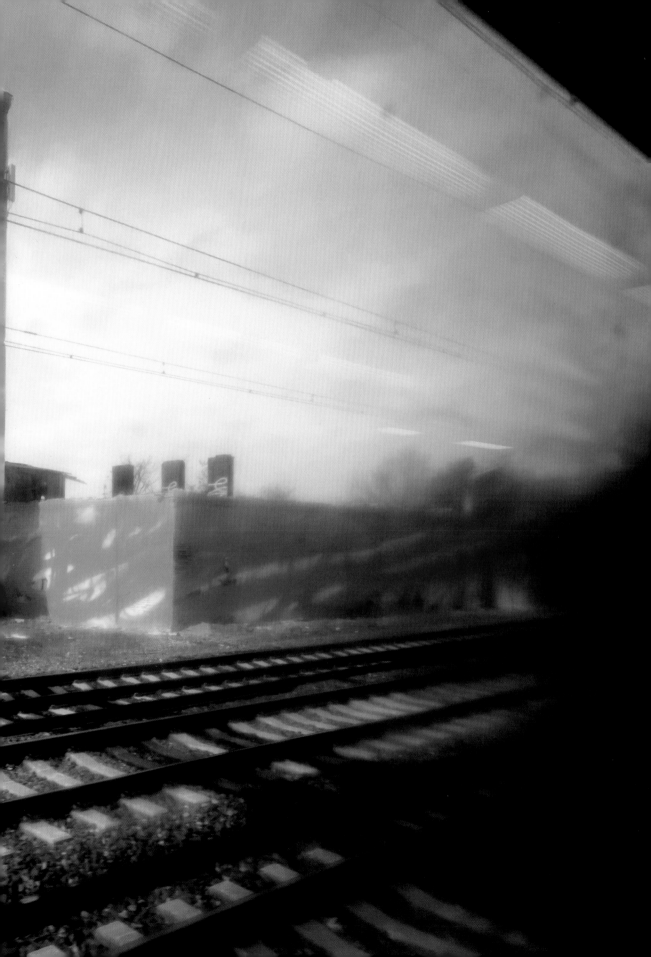

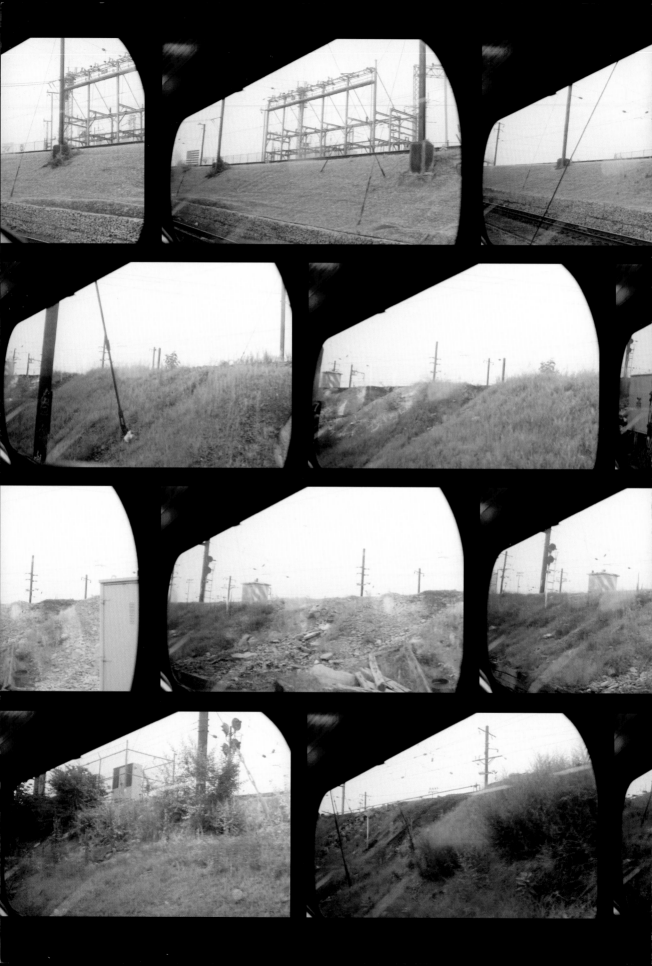

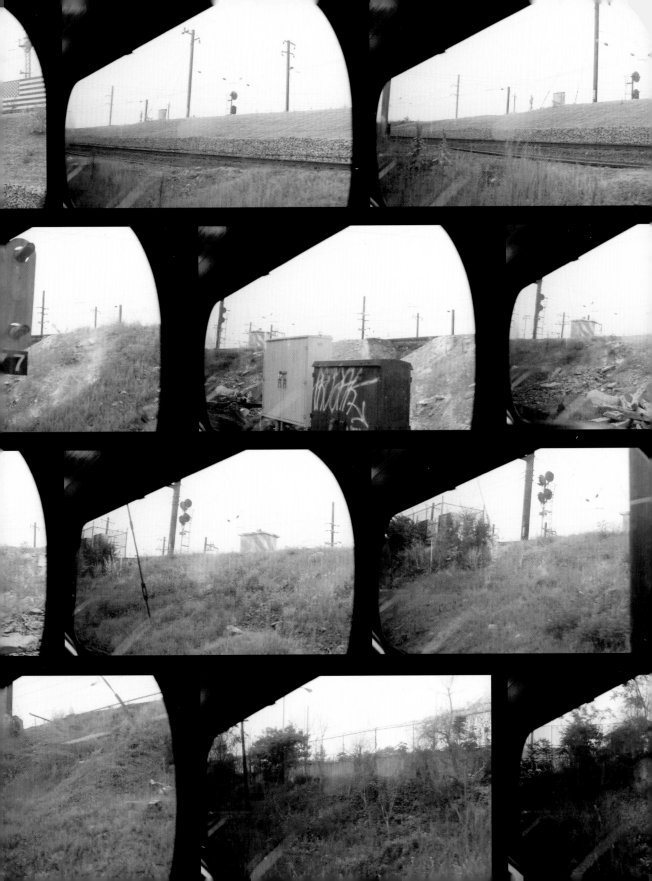

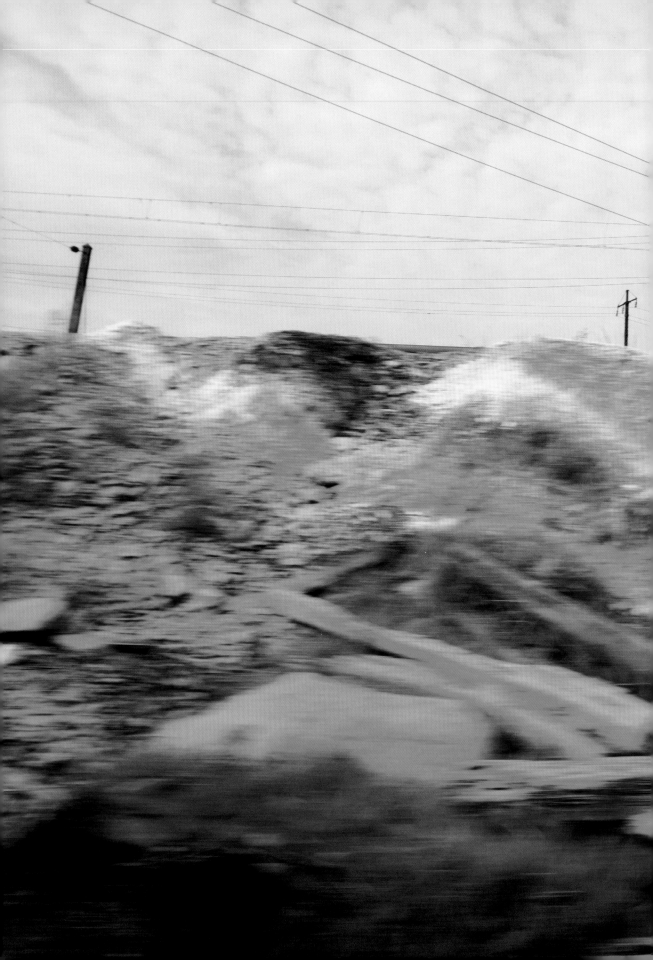

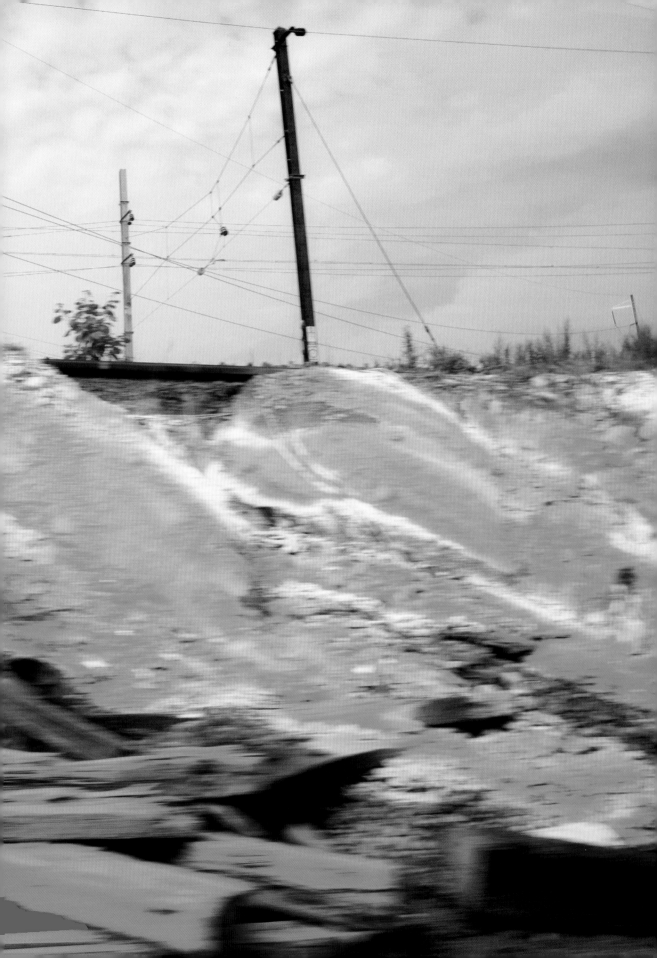

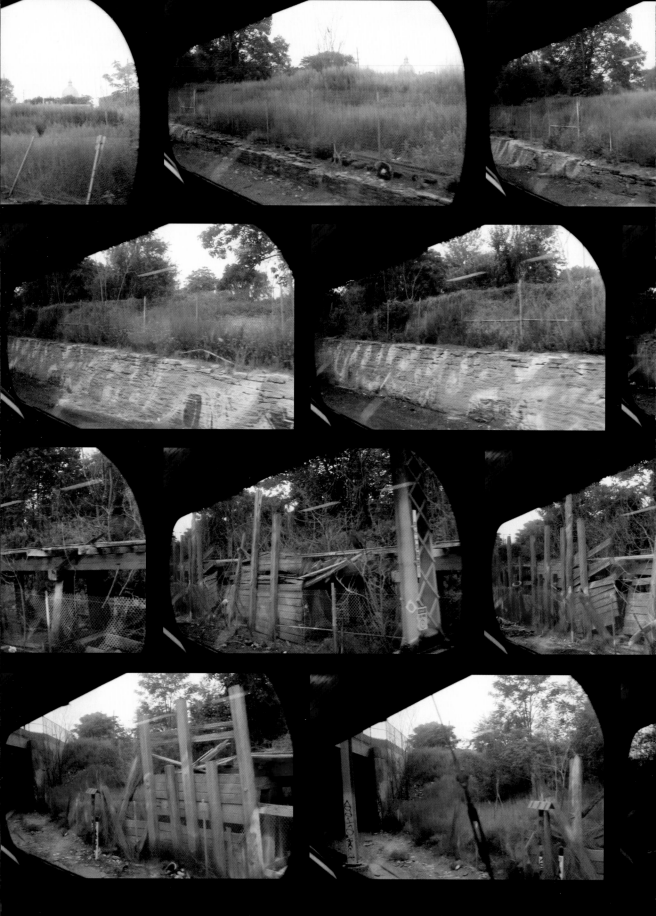

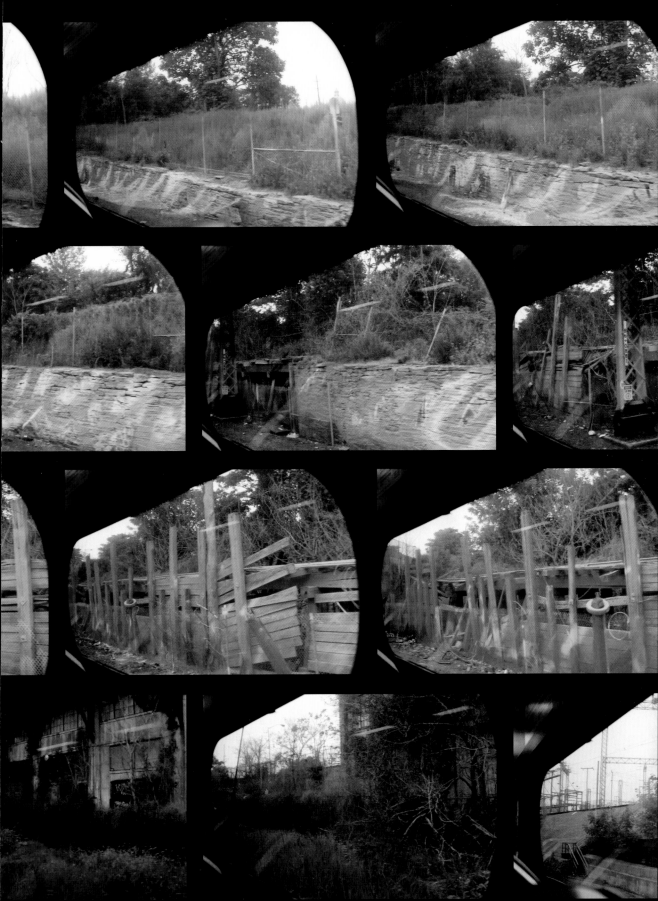

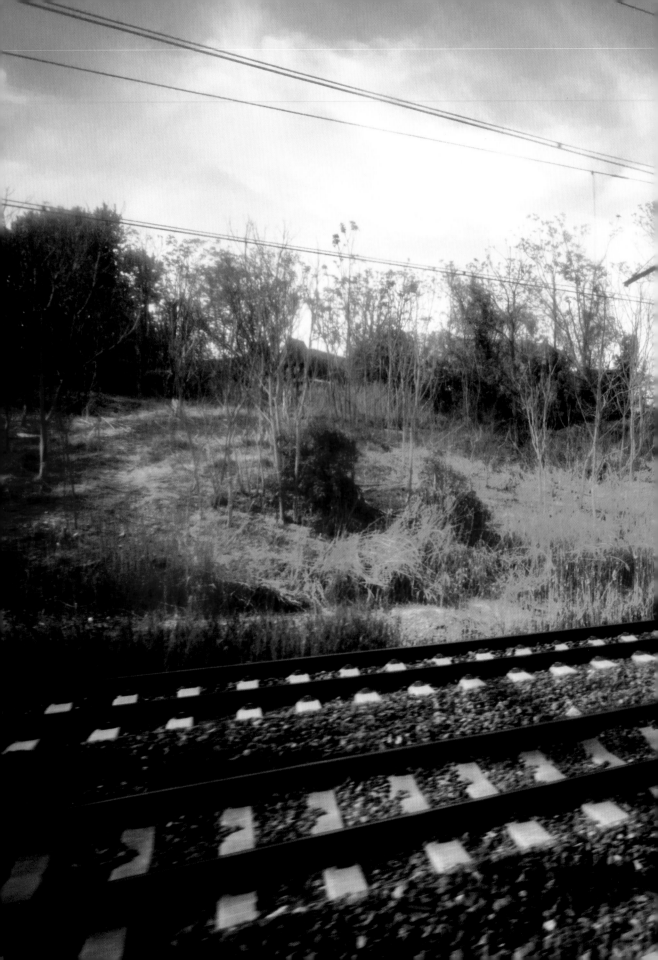

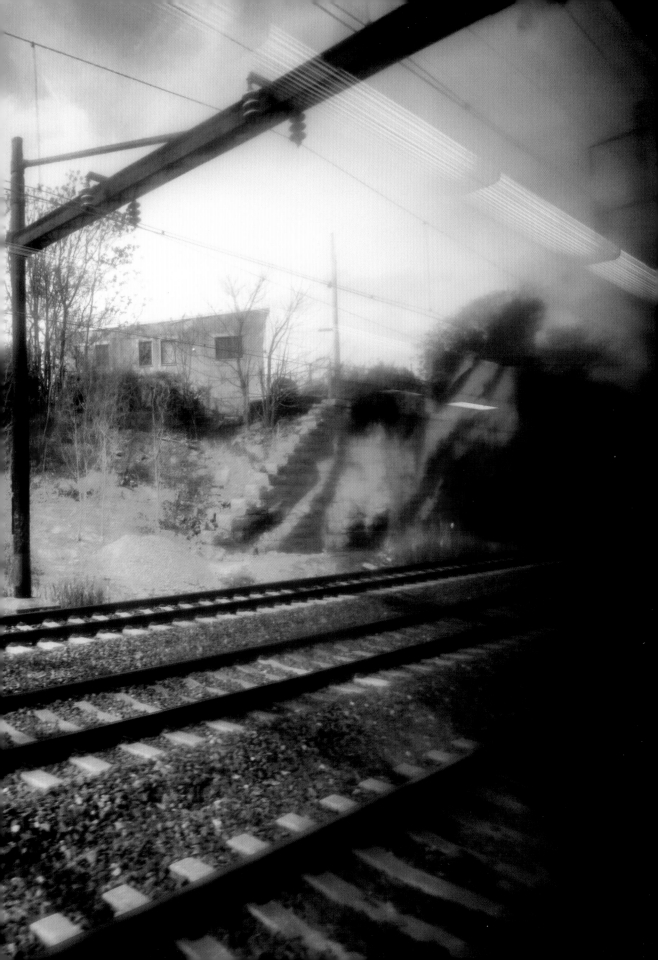